COLORFUL LIVING

COLORFUL LIVING

SIMPLE WAYS TO BRIGHTEN YOUR WORLD
THROUGH DESIGN, DÉCOR, FASHION, AND MORE

RACHEL MAE SMITH

TEN SPEED PRESS
California | New York

To my husband, Ryan, and
daughter, Evelyn.

Thank you
for filling my world
with color and joy.

CONTENTS

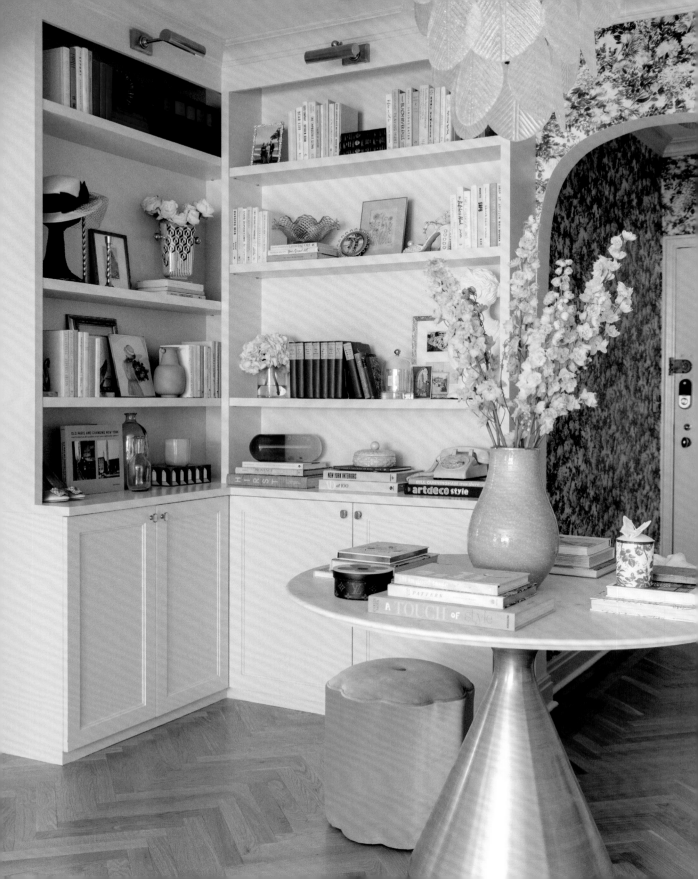

Life Without Color

ere's a secret about me: I wasn't always obsessed with color. In fact, I was passive about it for much of my life. Don't get me wrong, I've always *liked* color. I just never paid attention to it, how it appeared in my life, or how it made me feel.

You may know me from my current work as the blogger behind *The Crafted Life* and assume that my life has always been full of color, that color just comes naturally to me and I don't have to think twice about it. But for those of you who aren't familiar with my work: Hi, I'm Rachel, and I've created and shared accessible DIY projects to add color to people's lives for the past ten years. What started off as a hobby eventually grew into my full-time job. I owe a lot of my ability to make a career with color to being in the right place at the right time during the earlier days of the internet, but I also owe my success to shifting from creating just for fun to being mindful about color.

Despite my current work, my color journey didn't start until 2014 during a time when I was unhappy with parts of my life and my surroundings. I had just relocated to a city for a failing relationship and was struggling to keep up with my bills. This was also when I had turned my blog into a full-time job and money was extremely tight. I didn't have a dime to spend on anything other than rent and food, and even then, it was a stretch.

Taking the safe route and choosing default colors was a way to make life easier. When choosing décor for my home, I went with what would go best with everything else and products that were in stock instead of choosing items that actually made me happy. I thought these were wise financial investments. I didn't have to spend my mental energy on making decisions and I didn't want to risk my money on something boldly colored, even if I was drawn to it. I just let life happen to me. I didn't see the world around me and all the beauty it holds. I wasn't happy.

But in the end, being a passive participant wasn't the easier way, because I forgot about an important thing: joy. We all need a bit of joy in our lives to keep us going through times when it feels like nothing is working the way it should. Sure, I had furniture that matched, but that's where the positive ended for me. And I quickly regretted my purchases because it turns out that matching furniture isn't necessarily something you'll like in the long term. I didn't like how my own home made me feel and I certainly didn't get anything out of being in it. My home was simply existing in the same way I was.

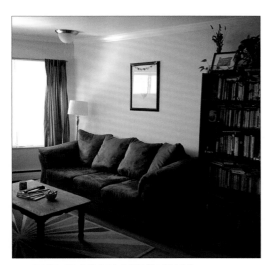

MY APARTMENT (2014), BEFORE COLOR

But one day while window shopping at a gift shop down the street, I came across a pack of Pantone postcards. If you're unfamiliar with Pantone, the company is best known for establishing a color system that acts as a universal language of color. People who work in design (fashion, graphic, printing, and so on) use the Pantone system to make sure the artist and manufacturer are using the same colors. Think of it like a well-indexed and expansive library of colors.

I had never seen anything like these postcards before. They were in a yellow box with one hundred color chip cards inside. On the back of each card was a place to write a note to mail to a friend or loved one. That pack of postcards made me feel a brand-new sense of excitement at the very core of my person, and I knew I had to have them. It was as if I had suddenly developed a creative interest that I had to explore. I scraped together the twenty dollars and took them home, excited to see more of the colors inside.

At the time, I didn't think anything special about the purchase; I just loved to fan out the color chips on my desk so I could see them all at once. Some colors, like cactus flower and chartreuse, I had forgotten existed in the world. And it wasn't because I hadn't seen them before, but rather that I didn't think about them, well, ever. I also found myself being drawn to colors for the first time in my life. There were so many shades beyond the classic ROYGBIV (if you don't remember, that's an acronym for the colors of a rainbow: red, orange, yellow, green, blue, indigo, violet). Who knew I could feel so much excitement about a particular shade of mustard yellow? The colors I thought I loved at the time turned out to be the least exciting part of the deck for me. And that's when I started to question things. What even was my favorite color? Why didn't I remember that chartreuse is so beautiful? That deck sparked something; it changed my relationship with color.

I started taking those cards with me on walks around my new neighborhood to color hunt. I would choose a card and then try to find that card's color out in the wild without any planning or

forethought. One of the color-hunting walks that has stuck with me was when I found this pop of yellow on an autobody shop that I used to walk by regularly. Before, it had been just an ugly space for beat-up cars and oil-stained pavement. But when I found this particular yellow on the trim of the old garage, my mindset changed and I started to look forward to seeing that shade of yellow in my day. What was once just a passing eyesore became this almost secret source of creative inspiration. I then made it a point to take that exact shade of yellow and bring it into my home so I could always feel that joy of discovery. It is a reminder that color is out there when you look for it.

PANTONE COLOR SWATCH CARDS

From there I had a color revolution that I couldn't contain. I wanted to experience color in all aspects of my life, so I started making small, seemingly insig-nificant changes. If I was creating a project for my blog, I started opting for a brighter color choice for my paints and materials. When looking for art for my new apartment, I found myself drawn to more vibrant pieces and photographs. As time went on, my wardrobe was starting to look how I wanted it to, and the change had nothing to do with the size or style.

Little by little, those small choices led me to where I am today—even though they seemed inconsequential in the moment. Developing an awareness of and appreciation for color was the push I needed to start changing other aspects of my life too, like moving on from that relationship and moving to a place where I

wanted to live. Now, after years of making conscious color decisions, I see the world in a completely different way. Essentially, that twenty-dollar purchase saved my life and changed my entire perspective. Five out of five stars, would recommend.

If you connect to the place in which I found myself years ago, you certainly aren't alone. Maybe you've moved to a new city and don't quite love it yet. Maybe you've lived somewhere for a long time and feel disconnected from your community. Wherever you are in this moment, in your life, I hope it's somewhere good. And if it's not, that's okay too. That just means there's room for growth, and I believe color can help you get there.

If you're just starting your own journey with color, I'm jealous! There's so much for you to explore and learn. To keep you from getting overwhelmed, I've taken the steps I took over the course of years and reduced them to my favorite tips and exercises so that you can start to find your own color connections faster. Feel free to work through these pages one section at a time. Or just pick a page at random whenever you have the time and energy to flip through for some quick color inspiration. Work at your own pace and do what's best for you.

I wrote this book to help you practice choosing yourself and what you like instead of what you think might be the safer option. If that's a rainbow-filled home, amazing. If it's calming neutrals you crave, let's find the ones that bring you peace. As you turn these pages, I hope they bring you closer to choosing excitement, inspiration, and joy over whatever feels expected. Or maybe it will just help you be in the moment and see your surroundings in a completely different light. Life is too short not to have fun—especially with color. So, let's get to it.

xo Rachel

The Benefits of Adding More Color to Your Life

*C*ongratulations! You have taken your first step toward a life filled with color. Whether you read every single page of this book or just flip through for inspiration, I hope your love for color will only grow deeper from this point on—because adding color to your life can be beneficial in so many different ways.

Sometimes you can't change a lot about where you live or what you can afford. But color gives you the freedom to work with what you have. With a little bit of creativity and redirection, color can give you control and help you pay attention to things you might be overlooking every day.

Can something as simple as color have any lasting impact or is the idea all fluff? How color can affect your mood, productivity, and day-to-day life falls under a branch of psychology called environmental psychology. Our environment (where we live, where we work or go to school, where we play) has a significant effect on our behavior and mental health. It can change how we feel about ourselves and how we treat other people. It has the ability to lift us up or bring us down. It can be the reason we start the day on the right foot or wake up in a bad mood. And color, as an important factor in our environments, has a direct psychological and physiological impact on us, whether we're aware of it or not.

Perception of color is also an evolutionary trait that we rely on for protection. It helps us determine if we're in a dangerous situation. For example, when spending time in nature, you might be more wary when a brightly colored snake or spider crosses your path because you learned in biology class that bright colors = poisonous. You can often tell that food might be spoiled (green mold) or undercooked (too pink) just by looking at it. We subconsciously rely on our sense of color to keep us safe and navigate the world.

But beyond color being part of our natural instincts, there are other benefits to bringing it into your life. You can use color to stay organized, whether that means building a custom organization system for your closet (see page 191) or your office or by tapping into your associative memories (read more about this in chapter 10 on page 200). Surprisingly, color can even help you shop less and save money (more on that later).

If you are lucky enough to be able to design your home, getting to choose the colors you love can provide a sense of control and ownership over a space. This is especially true for renters who have limited opportunities to make big changes at home. Color can help you create a space focused on relaxation to shed the stress of the outside world or one that makes you feel energetic after a long day at work. Making these decisions with care will help you improve everything from your environment to your self-expression and identity.

Please know that bringing color into your life does not mean you have to surround yourself with all the colors of the rainbow at all times. Of course, if that's what you want, go for it, but you don't have to be a maximalist to have a greater love of color. It's important to take your own culture and color history into consideration when bringing color into your life.

Now, painting a room your favorite color and hoping for a complete mental health overhaul isn't how exploring color will work , unfortunately. Imagine the amount of money we could all save on therapy if that were the case! The idea behind choosing color is that you're actually choosing *yourself*. You're exploring what you like, you're moving with intention, you're putting effort into where you live. It's so much more than color, but color is the vehicle and the method by which you get there.

This process is about finding joy through the medium of color. We're going to talk a lot about physical objects as well as color exercises, but we're going to focus more on the color of those physical objects and the feeling you get from them rather than on the objects themselves. In addition to the psychological benefits of adding color to your life, the idea of focusing on color can also put you in the mindset of choosing joy. You can shift your focus to intention rather than being passive. You can choose what you like and what makes you happy.

And many of these choices come down to the opportunity to add a bit of color to your day. We go through so many seemingly unimportant tasks throughout our days, but we are constantly taking in color. Instead of letting these colors (or lack of colors) just happen to us or viewing them as not important, let's start moving with intention. Even if that only means you decide to drink your morning coffee from a mug that's your favorite color. And even if that's all you do today, you're still making a conscious effort to incorporate something that makes you happy into your day. Choosing color will help you appreciate the small things in life. Do this a few times a day and suddenly you're moving toward happiness.

A QUICK AND PAINLESS INTRO TO COLOR THEORY

Color theory is so much more than a required course for artists and designers, and it's not a topic studied just for academic reasons. It's really a way to understand how colors interact with one another and how we as humans perceive the color around us. It can explain why we gravitate toward certain color combinations and why we don't like others. It can help us choose clothes that complement our skin tones or even help us create calm and nurturing spaces. Once you understand basic color theory, you'll have a stronger sense for how to use colors together so that they are the best and strongest they can be, as well as how to choose the colors you love with intention and understanding. There are countless colors in the world, but learning how to have a discerning eye when it comes to characteristics like hue and tone will help you find the exact shades that bring you joy. Colors that seem straightforward, like neutrals, still have hundreds of shades! And pairing them can be just as tricky as working with bold colors.

The main takeaway I hope you get from this chapter is a better understanding of the why and how of colors. Why does a color read warm? How do you adjust a color's base tone? *What is a base tone?!* Having this insight should help you select a color palette for your home, your wardrobe, and your life with more confidence. You can follow the color rules as you add more vibrancy to your life and begin to know what works for you—or you can learn the rules and then decide when and why to throw them out the window.

Basic Color Theory

Humans are trichromats, which means we have color cones in our eyes that absorb three base colors: red, green, and blue. Red is the first color we see (in the womb!) because it's the first cone to develop in the eye. From these three cones alone, we can perceive well over ten million different colors. In fact, every color we see is a shade and variation of those three colors.

What makes color perception even more interesting is that each person has different vision, meaning we each perceive colors in different ways. Those who are color blind may not have all three cones, limiting the number of colors they're able to perceive. But even if you and I have all three cones, I cannot know what you see and vice versa. With so many options (again, over ten million!), everyone will see or think about colors in different ways.

It's important to note that we tend to project our lived experiences and culture onto colors. Certain colors have meaning and significance to me just because of the life I've had and where I've lived, whether that's location- or culture-based. People who live elsewhere in the world or who have other backgrounds might perceive and use color in an entirely different light.

*"If one says **red** (the name of a colour) and there are fifty people listening, it can be expected that there will be fifty reds in their minds. And one can be sure that all these reds will be very different."*

JOSEF ALBERS
INTERACTION OF COLOR

With innumerable color shades and tones available in the world, and given how differently we each see them from one another, the question becomes "Can you really make a bad decision when it comes to color?" No, you can't. The only mistake you can make is to choose a color because you were told to, not because you like it. If that's not enough of a reason to just have fun with color, then I don't know what is!

While there aren't any "bad choices" or mistakes when it comes to color (as long as you're following what you like), understanding more about how certain colors are created can help you pick your favorites. Following are some common terms you will see in discussions of color.

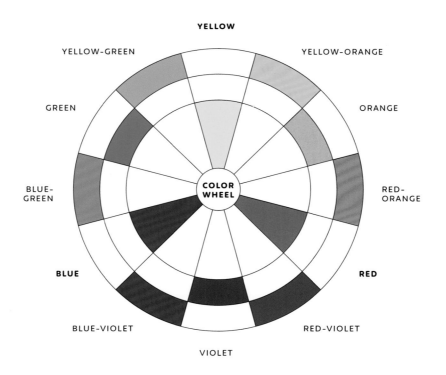

COLOR: a general term that refers to every possible shade of color we see

HUE: a specific color family seen on a color wheel

SATURATION: how much a color has been mixed with gray

BRIGHTNESS: how much a color has been mixed with white

VALUE: the overall lightness or darkness of a color

WARM COLORS: red, orange, and yellow and the different values they come in

COOL COLORS: green, blue, and violet and the different values they come in

COMPLEMENTARY COLORS: colors that bring out the best in each other when paired together; they complement each other. These pairings are opposite one another on the color wheel. Common examples are yellow + purple, blue + orange, and red + green.

When experimenting with color, getting your desired shade comes from the colors you mix. For example, say you want a sky blue. To brighten up the base hue of blue, you'll want to add white. The amount of white you add will change the blue's brightness. If you wanted a more muted sky blue, adding a touch of gray will lower the blue's saturation. No two colors are the same. Different shades of the same base color will create a completely different mood simply by changing one small detail in the base coloring. There are countless colors you could come up with by adding white and gray to your base!

To play around with this theory, use some acrylic paint. Pick up the basic ROYGBIV colors as well as white, gray, and black. Experiment with adding white versus adding gray or black to a base color. See what happens when you mix warm and cool colors together. Or try to match a color you already have in your house to get a better understanding of how it was made.

BLUE + WHITE, GRAY, OR BLACK: **COOL BLUE + WARM COLORS:**

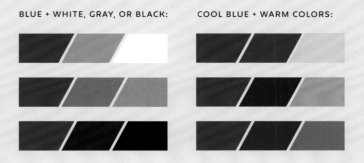

I think you'll quickly discover that colors are not as simple and straightforward as they might seem. Sometimes blue will have red, yellow, and white in it. Training your eye to be able to distinguish the layered complexities of a color will only help when you're deciding on colorful choices later in your journey.

Beyond the Rainbow

Beyond the typical ROYGBIV, there are some wildly unique colors that are worth getting to know. I urge you to explore beyond the common colors (one way to do that is by taking the Find Your Favorite Color Quiz on page 45).

One color in particular has a bit of a dramatic story—Vantablack. (As someone who loves reality television, of course I love it when there's drama in the art world.) Now, you might look at the color and think it's just black. And you wouldn't be too far off. But at the time of its creation, the color Vantablack was the world's blackest black, absorbing 99.965 percent of visible light. Because it is so dark, it appears flat and is an incredibly unique viewing experience.

The artist Anish Kapoor (who created the Bean sculpture in Chicago, officially *Cloud Gate*) bought the exclusive artistic rights from the lab in the UK that developed it to use the color. Meaning, no other artists could use the color.

This understandably sparked controversy in the art world, especially since Kapoor didn't create the color itself; he just secured the rights.

As a response, the artist Stuart Semple created what he refers to as "the world's pinkest pink." Was it the pinkest pink? Not exactly, but that, coupled with the fact that it was sold with the disclaimer that buyers could not be Anish Kapoor or be purchasing it for him, was all that was needed to show how Kappor's actions were received by other artists. As of 2019, there's an even blacker black on the market that absorbs 99.995 percent of all visible light. It's available for all artists to use.

This wasn't the first time that a color had been trademarked. International Klein Blue is a very specific formula that was a signature for the artist Yves Klein. He trademarked the color in 1957. And I bet you can picture the exact shade I mean when I say Tiffany Blue, another color that has been successfully trademarked.

Neutrals

What makes a color neutral?

When I refer to neutrals in a color theory sense, I tend to mean the classic neutrals. In my world, I will forever treat pink as a neutral color that goes with everything. But in standard color theory, there's a reason that neutrals are, well, neutral.

Neutrals are colors that don't tend to show up on a color wheel because they are almost completely lacking in saturation (meaning they have no gray added). A pastel-like pink is created differently, as I'll discuss in a second. Neutrals tend to fall under two categories:

PURE NEUTRALS: Think black, white, and gray in their purest forms (meaning, they haven't been mixed with any other colors to achieve an undertone). You can mix pure neutrals with fully saturated colors to change that color's luminance and vibrancy. You would mix a pure neutral with a saturated color to make a pastel (hello, pink!).

NEAR-NEUTRALS: When you mix at least two primary colors together, you create a near-neutral. For example: red, yellow, and blue mixed together gives you brown. From there, you could blend a near-neutral with a pure neutral to change the overall color tone. This is how colors like cream, beige, and taupe are created.

When it comes to décor, whether your palette is all gray and cream or you use them sparingly, neutral colors are a great way to achieve calm and balance in a room. Because of their lack of saturation, neutrals aren't as stimulating as other colors, so you can use a lot of them side by side without feeling overwhelmed. They also help to serve as a background for other colors and can even make another color appear brighter when placed side by side.

A neutral palette is a good place to explore texture and bring interest to an item. Keep an eye out for neutral-colored objects with unique shapes. You want there to be something visually stimulating about the piece when the color is more muted to retain interest throughout the years.

Near-neutrals can be tricky to work with because of how complex the base colors can be. There's an entire range of subtleties within a single color option. You really have to know the undertone of the color to understand how it will interact with your space or in your wardrobe. A cream with a warm base will give you a completely different feeling than a stark white. And when you buy two different cream items, they will probably look completely different from each other when placed side by side.

Nevertheless, neutrals are good additions to any color palette and will work with just about any design style.

Pastels

What are pastels?

Often calming and sweet, pastels are any color that's been mixed with white to lower its saturation and add brightness. The base color's essence remains, but when mixed with white, it becomes a lighter and softer version of the original color. Think of a classic rainbow, but add a large amount of white to each color.

COMMON PASTEL COLORS: millennial pink, peach, pastel yellow, mint, sky blue, lavender

Pastels are often associated with spring. They're used as a gentle way to move us from the desaturated tones of winter into intense summer colors. Think of them as an in-between phase to warm ourselves up to a brighter palette. This same idea can used to bring color into your life.

Pastels are delicate with an essence of saturation, which makes them good options when you're just beginning to add color to your home or wardrobe. Like lightly saturated neutrals, pastels have the tendency to complement more than they overwhelm. So, if you want to step out of the neutrals but aren't quite ready for jewel tones, start with pastels.

On the other hand, if you're already a fan of bright colors but want to create a bit of balance and interest, pastels make a nice pairing for just about any shade. For example, combine a deep and rich evergreen with mint or even a soft baby blue with navy. Pastels have a beautiful ability to enhance another color while remaining interesting on their own.

And finally, if you want to create a more monochromatic look, you can keep adding white to your base color to make it more and more pastel. This is a foolproof way to give yourself a range of colors that feels cohesive.

Earth Tones

What are earth tones?

In simple terms, earth tones are colors that, you guessed it, come from the earth; think the colors of soil, trees, mushrooms, anything you'd see while exploring a national park. These are colors you will see in the woods and in your own backyard. If you want to broaden the scope of these colors, you could even expand what you consider to be earth and include shades of blue for the sky and water, but for the most part, earth tones tend to come from the ground itself.

COMMON EARTH TONES: olive, moss, khaki, terra-cotta, rust, brown

Earth tones are slightly muted in saturation and have warmer undertones. For example, an earth tone shade of red would lean toward rust versus candy apple or pure red.

It's nice to use earth tones if you live in a city or somewhere with limited access to nature, to connect with the calmness you might find out in the outdoors—but honestly, they are wonderful additions anywhere if you like them. Along with bringing in plants, also think of adding earth textures. Items made from clay, stone, ceramic, and wood will help to reinforce a sense of nature. The textures of these natural substances will add even more depth and take your earth tones to the next level.

Jewel Tones

What are jewel tones?

Like the name indicates, jewel tones get their influence from jewels, in this case, gemstones. The color names also tend to be the same as or similar to the actual gemstone, so if you have a favorite piece of jewelry, chances are you'll be able to match it at the paint store. Jewel tones are boldly saturated and tend to be deeper and moodier colors, often mimicking the rich aesthetic of royalty.

COMMON JEWEL TONES: emerald green, ruby red, sapphire blue, amethyst, and citrine yellow

If you want to achieve a bold look without using intensely bright primary tones or neons, look to the jewel tones.

Because of their ties to gemstones, we tend to naturally associate jewel tones with sophistication and luxury. If you want to elevate your home décor while sticking to a modest budget, these colors can help you get there. Try bringing them into your life with lush textures and fabrics like velvet. You could even pair them with metallic hardware or go for a dramatic approach and layer different jewel tones together or with a pop of black. For a subtler approach, pair them with pastels and lighter-toned neutrals.

Even in small doses, jewel tone colors will make an impact. So whether you're accessorizing your outfit with them or boldly painting your walls from floor to ceiling, jewel tones are the perfect colors to use when you want to stand out and make a statement.

Primary Colors

What are primary colors?

Primary colors are considered anchor colors because they serve as the base for all other colors. In their purest form, they're fully saturated; meaning that no other colors have been combined or added to create them. And although there are only three of them, when mixed they can create endless new colors.

THE PRIMARY COLORS: red, yellow, blue

To complete the additional colors in the rainbow, you would mix the following:

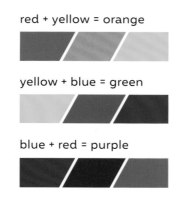

red + yellow = orange

yellow + blue = green

blue + red = purple

But the number of colors that primary colors can create doesn't stop at the rainbow. To make the tint of any primary color less saturated, add white. If you add enough white, you'll effectively change it to a pastel. Adding white and black or even gray could create an earth or neutral tone depending on the amount of color added.

Regardless of what you choose to mix them with, primary colors are a fun place to play around with color theory, because they are the base for the millions of color possibilities that humans can see. The possibilities are quite literally endless!

While primary colors are used to create all colors, they can certainly stand on their own. If you like bold, with primaries you have the color in its richest form. The high saturation of their color value tends to achieve very striking and bright designs. Use them to make a statement without having to put forth a big effort.

As you're meaningfully bringing color into your world for the first time, you may want to reserve primary colors for accent pieces or otherwise use in small doses. That amount of saturation could be overwhelming if it's not balanced. But as long as you're having fun and they're bringing you joy, I say lean into the primary!

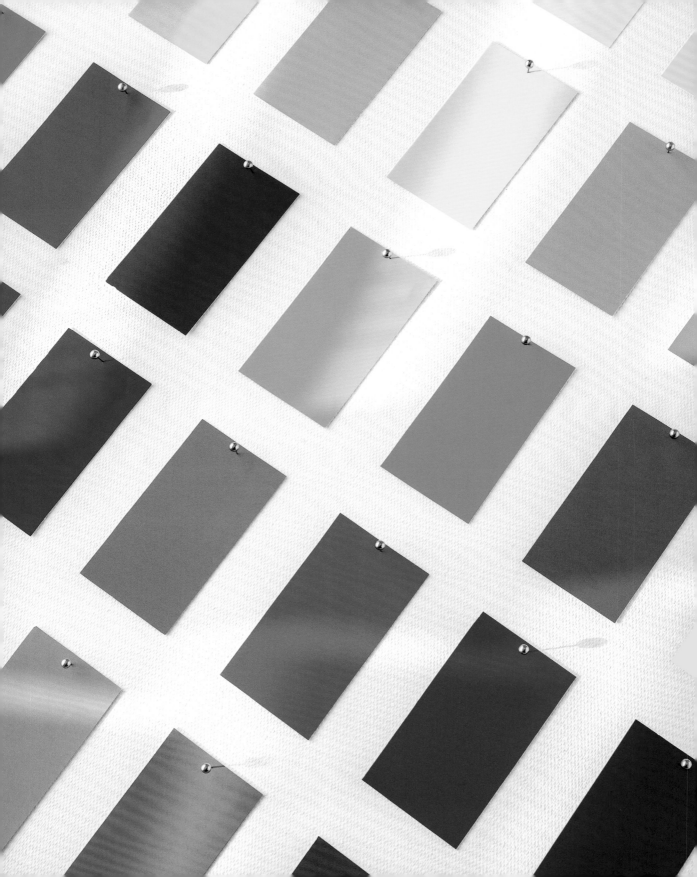

Quiz:
Find Your Favorite Color

It's said that humans can see more than ten million different colors. But because we humans perceive color so differently from each other, there might be an infinite number of colors in the world. With so many options, it's easy to see how you might feel overwhelmed when choosing your favorite color. That's a lot of choices when it comes to finding THE ONE. Instinctually, despite all the options out there, you'll recognize your favorite color (even if it's just for the moment) when you see it.

To narrow things down, it helps to start with one of the colors of the rainbow and then branch off into that color's different hues to help get you closer to a favorite. You might already be drawn to a certain color, or your gut will tell you where to start once you look at the colors on these pages. Maybe it's because you have positive memories with a certain color or it's been present in your life in positive places or during happy experiences. Regardless of the reason, let's start with the base.

You know the classics of ROYGBIV:

R—RED	O—ORANGE	Y—YELLOW
G—GREEN	B—BLUE	I—INDIGO
V—VIOLET		

But also consider brown, gray, black, and white as basic colors.

Out of these main choices, what color brings you the most immediate joy? It will be the color family that makes you smile. Use that as your starting point (flip to the page that has your general color) and then consider the various shades of that color and ask yourself the following questions.

1. Let's start with luminance, or the brightness of a color.
 Do you prefer a lighter color (think: pastel) or a darker color?
 Or maybe something more in the middle? Head to the row
 of shades with your desired luminance.

2. Now it's time to pick a base. Do you like cooler undertones
 or warm?

This quiz doesn't include ten million options for you to
choose from, so if you are not happy with your results, I urge you
to explore your color family (or another one!) until you find the
shade that you can point to and say, "That's it—that's the color!"
Our tastes change and evolve as we age so you may find
yourself coming back to this quiz again and again. You can also find
additional colors you love for your second and third favorites, just
to have as backups. I hope that you'll use this as a starting point to
find the colors that bring you the most happiness.

↑ More BLACK

More WHITE →

← More PINK

More YELLOW →

RED

Do you prefer hot or colder weather? Do you like to stand out in a crowd or blend in? What's your favorite holiday?

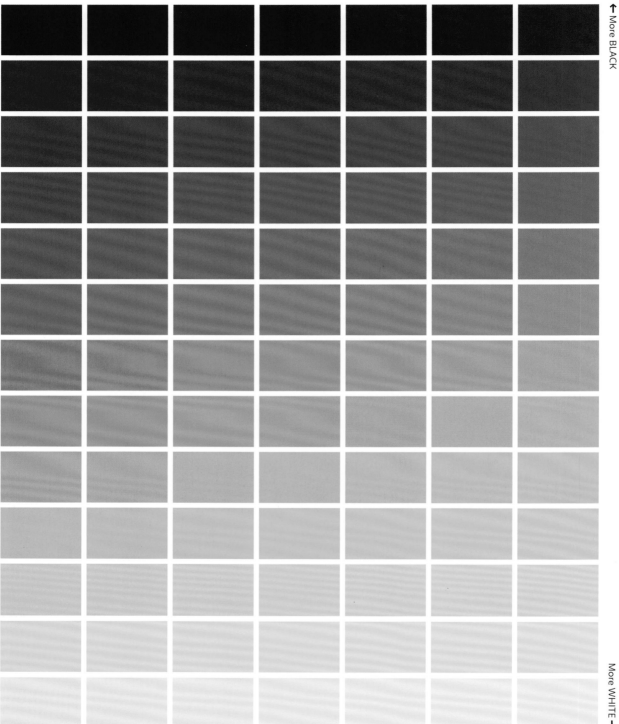

↑ More BLACK

More WHITE ↓

← More RED

More YELLOW →

ORANGE

What's your favorite fruit? Are you a morning person or an evening person? Do you enjoy sunrise or sunset?

↑ More BLACK

More WHITE ↓

← More RED

More BLUE →

YELLOW

Do you like a retro vibe or vintage finds? The soft pale yellow of spring? Maybe the pure sunshine on a summer day?

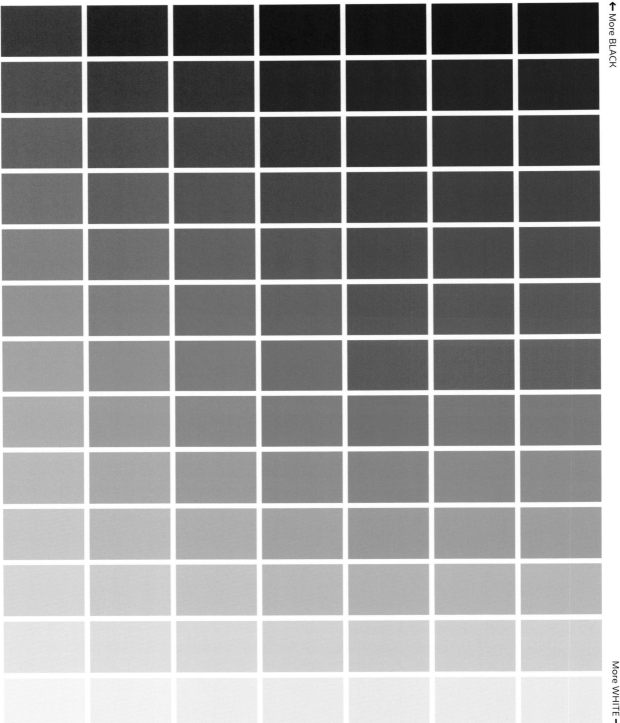

← More YELLOW

More BLUE →

GREEN

Do you like being out in nature or hiking in the woods?
Do you prefer something moody or more uplifting and joyful?
What about the smell of fresh-cut grass?

↑ More BLACK

More WHITE ↓

← More YELLOW

More RED →

BLUE

What time of day has the best color of the sky?
Do you like being on the beach in the summer or the winter?
Do you prefer being poolside or oceanside?

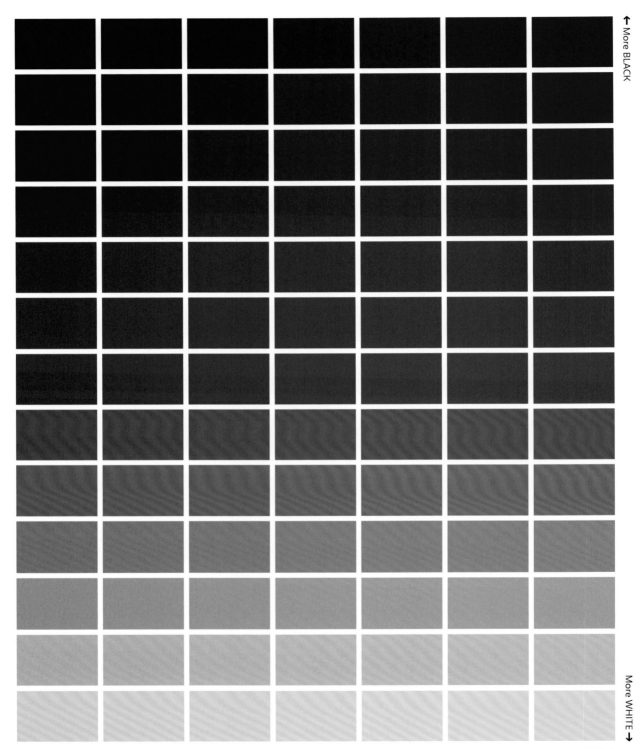

↑ More BLACK

← More BLUE

More RED →

More WHITE ↓

PURPLE

What's your favorite season? Do you prefer velvet fabric to silk?
What's your favorite flower?

More BLACK ↑

More WHITE ↓

← More BLUE

More YELLOW →

PINK

Do you prefer parties that are chill or upbeat? Do you like to go out or stay at home? Do you like spicy foods?

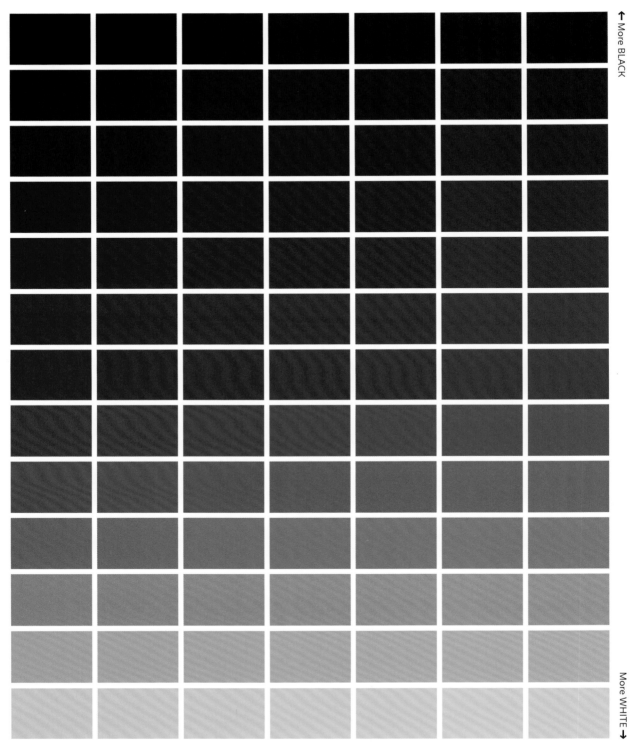

More BLACK →

More WHITE →

← More RED

More YELLOW →

BROWN

Do you add creamer to your coffee or tea? Do you prefer leather or fabric-covered chairs? Do you prefer to camp or stay in hotels?

More BLACK ↑

← More WHITE

← More YELLOW

More RED →

GRAY

Do you like visiting large cities and looking at skyscrapers?
Do you prefer industrial design? Silver or brass?

Chapter 3

Building Your Color Palette

*I*f color can enhance and alter our moods, then being selective with the colors we bring into our lives should be high on our priority list. When we control the colors we have around us, we can affect how our spaces and possessions make us feel. Beyond designing purely for aesthetics, there's power in being able to create a space that enhances your desired mood, whether that's creative, calm, energetic, introspective, peaceful, or whatever. So what's the secret to designing for a mood? The short answer: creating a color palette.

Getting Confident with Color

Starting with a simple color palette is a great way to begin any project. It serves as a basis for the decisions you must make when it comes to filling your world with color. Having an established color palette helps to ground me and keep me on track when I'm faced with endless choices, ideas, and products. Keeping the focus on color is by far my best tip for how to beat choice paralysis or avoid overconsumption.

Even if you start this process with an entirely new color palette, you don't need to make over your entire life in forty-eight hours. This isn't a renovation show and you don't have to swap out everything you own for something new. The idea here is that you get to *intentionally* choose colors for your life. I want you to focus on quality over quantity, joy over convenience. Fill your home with sweet memories, special items, and your favorite colors instead of following the latest trends. Having a color palette will give you some restrictions, but in a good way.

It may take a while for you to grow your color confidence, so don't be discouraged if this information doesn't click right away. The methods and ideas in this book took me years to develop and learn. And when I first started decorating my own home, it took me at least a year or two before I felt like I was getting the hang of it. I've found that if you're able to successfully tackle a single project, it will make you excited and more prepared for the next one. So maybe start with a small room, or even just a corner of a larger room, that you want to change. Maybe it's a space that you walk by or see every day so you can feel proud of the changes you made and be inspired to continue to other areas.

The beauty about working toward color confidence is that the more time you spend carefully selecting colors now, the easier color choices will be in the future. You'll go from laying out a bunch of choices and maybe feeling a bit overwhelmed to knowing in your gut what colors you want and why. Because the end goal is for you to be intentional and thoughtful about the choices you're making for your home and for your life.

So, let's make a color palette plan!

What Makes for a Great Color Palette?

Now that you know why it's helpful to have a color palette, let's talk about what makes for a *good* color palette. Of course, remember that colors are subjective, so at the end of the day, the ones that bring you joy are the best ones. But a simple, foolproof way to build a good first color palette for your living room, for instance, is to stick to five or six colors: a main color, a secondary complementary color, two to three accent colors, and a neutral.

MAIN COLOR: Simply stated, the main color is the predominant color of the room despite there being other colors in the space.

SECONDARY COMPLEMENTARY COLOR: This is the second most used color in the space. It should complement the main color by either bringing balance (think warms and cools; warm colors tend to stimulate while cool colors calm, and having a balance of both can bring peace to a room) or enhancing it (perhaps by expanding a monochromatic theme with a different shade). There's slightly less of this color used in the space when compared to the main color, but it still has a presence.

ACCENT COLORS: These are beautiful and supportive colors. They are used to bring out the beauty of the main and secondary colors and appear less frequently. Think of these as garnishes on a plate; they complete the dish in a visually stunning way. If they're not there, the main course isn't entirely different, but it might just be missing a little extra oomph.

When bringing in accent colors, be open to trying multiple shades to give yourself some flexibility and variation. For example, if you want green to be one of your accent colors, it's okay to bring in lighter and darker shades (think mint + emerald) instead of trying to make an exact match in every instance.

NEUTRAL: Most spaces will have a neutral of some kind, even if you are a ROYGBIV person. They help bring balance to a room and they make other colors pop. Neutrals provide a moment of calm for the eyes and can enhance your main and secondary colors. It's always a good idea to include neutrals in your palette, because most homes have neutral items (like floors or ceilings) that can't really be changed without a big makeover project. Incorporating into your palette any existing colors that are staying will help everything look seamless.

If you have a chance to decide on a neutral, look for one that has similar or complementary undertones to your main color. For example, if you want a cool and calm space and blue is your main color, you might want your white or gray neutral to have a blue undertone. If you want to bring in warmth to balance the cool of your blue, choose a white or gray with a warm undertone like yellow or orange.

The following three color schemes can help you start building a color palette simply by looking at a color wheel:

TRIADIC: This scheme involves colors that are three colors apart from each other on a color wheel. Some examples include red, yellow, blue; red-orange, yellow-green, blue-violet; or yellow-orange, blue-green, and red-violet.

ANALOGOUS: These are colors that are right next to each other on a color wheel; for example: blue, blue-violet, and violet; or yellow, yellow-green, and green.

MONOCHROMATIC: This final scheme includes all the varieties of a single hue; for example: pale blue, sky blue, and indigo; or light green, grass green, and army green.

And since I'm not one for strict rules, know that you can build a good color palette by going off the guided palette path too!

To have a minimalistic theme, just use three colors: the main color, a secondary color, and an accent color. In this case, you have to pay close attention to the shade of your items so as not to clash. For example, white can sound like an easy neutral to choose, but there are endless shades of white that, when brought all together, have noticeable tonal differences. A minimalistic theme can be done and done well, but allowing for more colors in your palette will always give you more flexibility.

On the other hand, if you're going for a maximalist look, you can of course have more than the recommended number of colors, but definitely give yourself a cap to avoid becoming completely overwhelmed with choices. When bringing in additional colors, make them accent colors so you don't take away from the main and secondary colors.

Regardless of the route you'd like to take when it comes to color, it can also be helpful to determine your design style. For example, if you favor an eclectic design style like grandmillennial, aka granny chic, it would be difficult to achieve that look (which uses pattern-clashing styles) with a limited color palette. Keep the style of your space in the back of your mind when building your color palette.

If you haven't determined your dream design style, there are a few things you can do to help you narrow it down. Try taking an online quiz (search "design style quiz" and several options should pop up). You could review home décor images through the decades to see if you gravitate to any specific style or color scheme. If you prefer to explore offline, visit your local bookstore or library and roam the home décor section. Pick up any book that calls to you and start researching the author or style to learn more. Feel free to mix and match as you see fit to create your own style! Remember, you don't have to be tied down to one specific style and stick to it one hundred percent of the time. For example, say you like elements of mid-century design. That doesn't mean you have to stay true to every detail of the era. This is especially true when it comes to colors. Sometimes swapping out the color palette can make an item feel vintage and fresh at the same time.

These same color palette guidelines can be applied when adding color to your wardrobe or any other area of your life. Start with the colors you cannot change (maybe you aren't replacing some key pieces in your wardrobe), choose the colors you look best in (the ones you can't change), and then add accent colors with your accessories. Read more about finding the colors you look best in on page 174.

My Favorite Color Palettes

Floral

MAIN COLOR: millennial pink

SECONDARY COLOR: coral

ACCENT COLORS: chartreuse, emerald green

NEUTRAL: brown

Moody Blues

MAIN COLOR: dark blue

SECONDARY COLOR: haint blue

ACCENT COLORS: emerald green, lighter green

NEUTRAL: blue-gray

Nantucket

MAIN COLOR: sky blue

SECONDARY COLOR: navy

ACCENT COLORS: white, lilac, tan

NEUTRAL: slate gray

Modern Rainbow

MAIN COLOR: pink

SECONDARY COLOR: orange

ACCENT COLORS: yellow, blue, light blue

NEUTRAL: white

Bright Bedroom

MAIN COLOR: bright teal

SECONDARY COLOR: mustard

ACCENT COLORS: linen, orange, pink

NEUTRAL: warm brown

Luxury Hotel

MAIN COLOR: deep teal

SECONDARY COLOR: rich brown

ACCENT COLORS: eucalyptus, mauve

NEUTRAL: cream

Minimally Bold

MAIN COLOR: white

SECONDARY COLOR: light gray

ACCENT COLORS: cobalt blue, orange

NEUTRAL: reddish brown

Classic Prep

MAIN COLOR: lavender

SECONDARY COLOR: pastel blue

ACCENT COLORS: light brown, white, brass

NEUTRAL: moss or mint

London

MAIN COLOR: red

SECONDARY COLOR: white

ACCENT COLORS: bright blue, green, pink

NEUTRAL: deep brown

If you're not sure where to start with your color palette, try these no-fail color pairings as your base to build upon. Here are my personal favorite color duos:

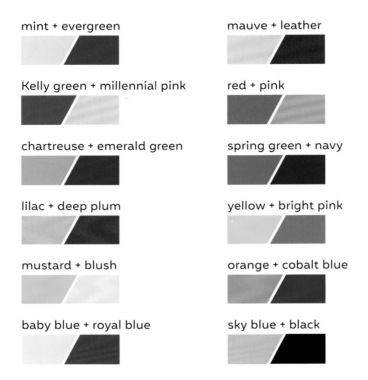

mint + evergreen

mauve + leather

Kelly green + millennial pink

red + pink

chartreuse + emerald green

spring green + navy

lilac + deep plum

yellow + bright pink

mustard + blush

orange + cobalt blue

baby blue + royal blue

sky blue + black

What are your favorites? Go back to the color quiz on page 45 if you're having trouble deciding. These could end up being your main and secondary colors or some of your accents.

How to Build Your Own Palette

The first thing I like to ask someone who is building a new color palette is "What is your favorite color and where do you see it in your home?" More often than not, we don't use our favorite colors in the décor we see on a daily basis. So, the first step to creating your palette: Always keep joy at the forefront of your mind when deciding which colors you want to bring home.

Another factor to consider is the items that are already in your space that you know won't be changing. If you don't have the budget to buy all new furniture or if you're renting and can't pull off a full renovation, that's okay. Actually, it's more than okay, because having a color palette for your home is all about finding joy and working with what you have. Instead of dwelling on what you don't like about your current living situation, let's find a way to enhance it. Don't ignore the existing colors because you don't like them. In fact, once you include these un-favorite colors in your palette, you can choose favorite colors that complement them and make the space feel more in sync.

For example, the floors of my apartment are a reddish-orange brown, very warm and bold. When making my own palette, I had to make sure the colors I like weren't in complete opposition to my floors. While I may have wanted to paint something a very golden yellow, it was helpful to know how much brighter that yellow might look against the floor or how the colors could clash with each other. My apartment could very well have read as ketchup + mustard, and if that wasn't my intention, I might have regretted my decision.

Next, consider the lighting of the space you're designing. Lighting has a big influence on how we digest color. Do you get a lot of sunlight in the morning? How does your space look with the waning afternoon light? Do you have small windows and want to brighten things up? Remember that opposites can bring balance. For example, if your room doesn't get a lot of natural light, a bright white or even a pastel with white as the base could counteract the gray light. You may need to go brighter than what you might like simply based on how the lighting works in the space. When in doubt, bring the colors you want to use into the space itself (either with paint samples or physical items themselves) and see how you feel. Color is relative, so the other colors around your choices will either enhance what you have or change them to a look you didn't intend.

Consider the function of the room and how you want to feel in the space, too. If it's a workshop or office and you want to boost creativity, try yellow. The more saturated the color (this is especially true with warmer colors), the more energy it will bring to a room. If it's a family room where you spend time playing with your kids, maybe you want a bright pastel-like millennial pink. It's just enough color to bring a sense of playfulness, but also subtle enough to not overwhelm. Or maybe you're working on the tub area in your bathroom and want to create the feeling of a spa (colors like sage, blue-gray, and cream can make a space feel tranquil).

I suggest making a color palette for each room or space in your home if you want to have a variety of colors. You could use

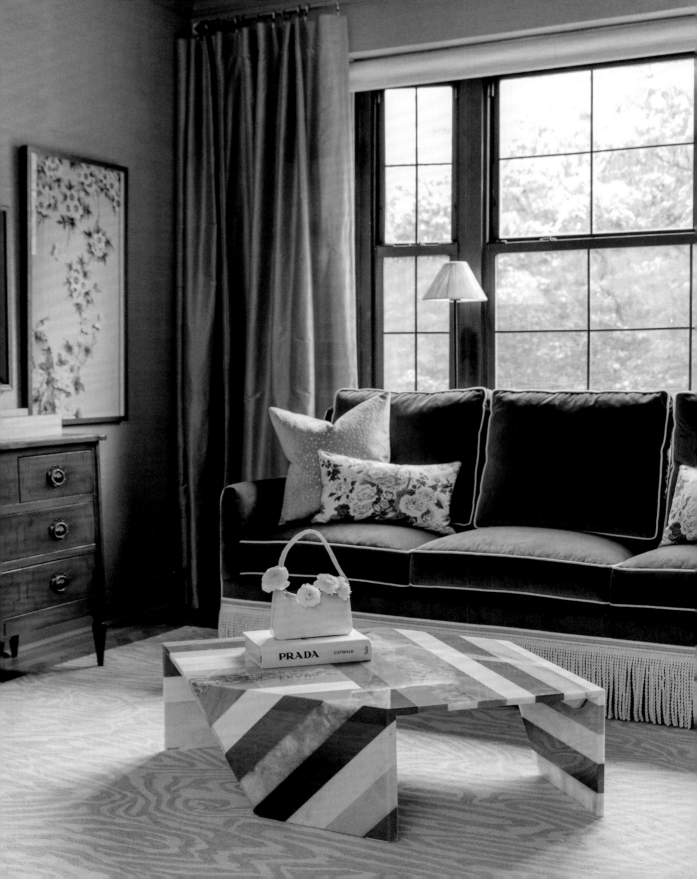

some of the same accent colors throughout to tie the entire home together if you crave cohesion.

Head to the hardware store to browse paint swatches. You don't need to consider any of these colors for paint (unless you're thinking about painting; in which case, first read chapter 5 to learn more about adding color to your walls), just focus on general color

Color Exercise: Build a Color Collection

While you're at the store, pick up some swatches to use for color hunting (see page 200). Really, having a collection of color swatches on hand is never a bad idea.

I'm kind of old school and love paint swatches, but if going to the hardware store isn't really for you, try working in a different medium. Maybe break out some acrylic paints or colored pencils and hand-make your palette. Or create one in Photoshop or other design software. Use the free resources available online from paint companies. They often show colors they've tested and applied to real homes (be careful of the generic mockups that only use computer-generated color). Their suggested color pairings can be a good starting point too. You could even gather items you already have to get a better sense of your existing colors and then build your palette with physical inspiration. Whatever method suits you best and helps you create is the way to go.

choices. You might want to try a few different stores since many will carry different brands with varying pigments of color.

Pick up any swatches that call to you and don't worry about putting anything together until you're back home. You can try grouping some colors while you're there to get a feel for the options, but you could also just select a few samples of each (bolds, pastels, earth tones, neutrals, and so on) and narrow them down once you're in your space with your possessions around you.

Working with Your Colors

Now that you have your palette, you might be thinking, what do I do with it? Whether your palette is physical, digital, or just some-thing that remains in your memory, use it from this point on as a guideline to everything you bring into your space. When shopping for items online, sort by the colors in your palette instead of looking at every item in every color. If you prefer to shop in person, have your palette as a copy on your phone or toss the swatches in your bag. You might find that the more you expose yourself to your set colors, the more often you see them in the wild. You'll also start to notice other colors you could pair with them. The more familiar you are with and the more often you use your palette, the more confident you'll become in bringing those colors home.

What do you do if you want to add a multicolored rug to your room that does not contain every color in your palette? First, ask yourself a few questions. Does the rug have a main color? Is that color in your palette? Do the rug's accent colors (the smaller, supportive colors) complement the colors of your palette (maybe they are different shades of colors you're using), or are they completely different?

Having six colors in your palette does not mean that you only have six colors in your home. They are the main colors that you have chosen to decorate with. Life will bring in other colors through photos, everyday items, appliances, and so on. There's no way to avoid having additional colors. But what the palette does is create an overall aesthetic for everything else in the space and give you guidance on what to look for or DIY if given the option. If you use your palette colors widely enough, then having other colors outside of them will still feel cohesive.

You can be as strict or as loose with this as you want; it's really up to you and whether you're enjoying the restrictions of working with a color palette. Make your own rules! Let this be a starting point, and allow your likes and dislikes to lead you from there.

Oh No, It's Not in My Color Palette!

If you come across something that you want to buy for your home but it's not in your color palette, what do you do? The enabler in me wants to tell you that life is short, go ahead and buy it. But that can be a slippery slope to muddying the color palette you have chosen and worked hard to implement in your home. Instead, I like to run through a series of quick questions before making any spontaneous purchasing decisions or bringing anything new into my home.

1. *Is the item unique, vintage, or significant?* There's always space for memories and family heirlooms since these items add to your personal story. If the item is instead mass-produced, like something you might find at Target, you might look at the value it would bring to your home. If it's functional and you need it to serve a purpose, then sometimes it won't come in the color you need and maybe you should buy it. But if it's a decorative item, then I continue with the questions.

2. *Do I already have something else like this at home?*

3. *Does it fulfill a specific desire or was this item on a wish list?*

4. *If I put it back and walk around or even leave the store, do I still think about it?*

5. *Could I find something better or more "me," or possibly in the color I want if I wait and shop around?*

6. *How is the quality? Will this piece last for years to come?*

When it comes to color, I give myself some flexibility, because tastes do change and evolve over time. If the item is not a perfect color match, maybe it's in the same family (for example: baby blue is in my palette, but my item is cobalt blue). Or maybe this item could function as a bold statement piece. Or perhaps it at least complements my palette.

If what you're considering is too good to pass up, do it. Anything that fills your heart with joy should be listened to. But make sure it's not just an impulsive feeling, but instead one that's going to last and grow with the rest of your home.

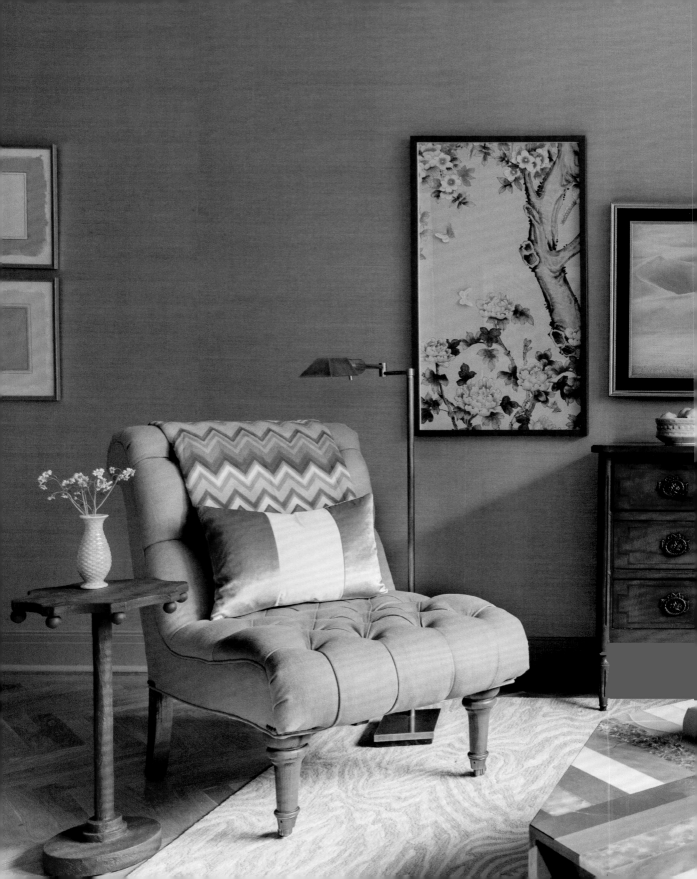

Take a Seat (Your Furniture Doesn't Have to Match)

GRAHAM GREENE'S Classic Tales of Espionage and Suspense

CHITNIS PATTERNS of INDIA

YVES SAINT LAURENT haute couture CATWALK

*O*ur homes are our personal sanctuaries—the space in this world that is completely unique to us, where we can create an environment just for our needs. With the rapid growth of home décor content online, it's hard not to be overwhelmed by peering into the homes of others. But do your best to stay grounded: Think of your home not like a museum that's perfectly styled for a photo in an instant, but rather the place where you want to live and make memories. A home doesn't have to be picture-perfect to be perfect. Your home should be your place to reset and recharge, where you feel secure: a space that reflects who you are in a way that makes you feel good about yourself.

The beauty of home décor is that it gives you the ability to write yourself and your personality on any blank room. You can use physical objects, paint, wallpaper, furniture, art, and so much more to reflect who you are. There's so much potential to reflect our preferences, our memories, and, of course, our favorite colors. Everything you have in your home is an opportunity to create a special moment.

Traditionally, home decorating is the art of enhancing your home's aesthetic with objects and furnishings. But beyond looking at your space with an eye for only physical pieces like tables, vases, and rugs, I want you to look at it through a lens of color. Think of color as an element with as much weight as your physical pieces of décor.

Color Exercise: Create a Mood Board

If you don't feel like you know anything about home décor, do a little research before starting your projects. Websites like *Architectural Digest* and apps like Houzz and Pinterest let you browse thousands of interior design photos, which is a good way to discover what you do and don't like. I start with a mood board, which is a collection of inspirational images that represent the look I want. (Don't forget to add your color palette to your mood board!) You could create one online using a Pinterest board, cut out images from design magazines, or check out design books from your library. This research will help you build confidence about the aesthetic you want to have in your home.

The ideas in the following pages are not meant to be completed overnight. You might not even get to all of these projects within the year. Remember that you're on a color journey. Work at your own pace, according to your own budget, and you'll end up with great results. Take your time!

When it comes to home décor, it's easy to be impulsive. When we see a need in our home, we want to buy the first thing we like just to check it off the to-do list. It's harder to wait, shop around for the perfect fit, and make sure your find will be a piece you're going to treasure for years to come. I know that's a lot of pressure to put on a purchase. And the truth is, you might change your mind and your style next year. But when you become intentional about the colors you choose and stick to your chosen color palette, you've taken two big steps toward house joy.

While furniture at its core is functional in purpose, it also has the power to carry the design aesthetic for your space. Different shapes, colors, and textures evoke a variety of styles and designs that reflect a specific era or aesthetic. For example, you might associate a couch or table with thin tapered legs with mid-century modern design, or rough textures and exposed beams with modern farmhouse. In both examples, the design aspects can be reinforced with color.

Choosing a pink sofa may not be for the faint of heart and it's certainly not for everyone. But in the grand scheme of life and everything that humans endure while we're here, buying a colorful sofa seems like a low-risk endeavor, especially if you enjoy pink! And surprisingly, choosing a piece of statement furniture like a bright pink sofa, or even funky patterned chairs, is a lower risk than you might think. According to researchers at the University of Miami, humans are more likely to hold on to bold designs over time because we crave a moderate amount of stimulation so as not to get bored. So while a bright piece of furniture may seem shocking right now, bolder designs might remain in your home for longer than you think. Cheers to being bold!

Five Ways to Add Color to Your Furniture

1. Paint it.

There's nothing a good coat of paint can't fix. Before splurging on a new and more colorful item, try painting something you already own. Paint can change the feel of a piece and is often a budget-friendly way to refresh a room.

If you don't already own the piece, consider scouring your local thrift stores, garage and estate sales, or neighborhood buy-and-swap communities to find affordable pieces that you can paint. Sometimes if you drive around your neighborhood the night before trash pickup, you'll spot some unique and free finds curbside.

Also, you don't have to paint the entire piece of furniture to get an impact. Got a table? Try painting only the base a bold statement color. Or add a colorful trim to a console or media table. Sometimes a little bit of color goes a long way.

Simple Painting Tip

The process of painting furniture may seem involved, but you can absolutely break it up over several days or weeks if you want. Remember that you are striving for longevity with your furniture, so don't rush or skip through the steps just to finish, or you might be doing touch-ups or repainting sooner than you'd like. It will require some elbow grease, but the end results will absolutely bring something totally unique to your home. Consider working on pieces with other members of your home so that when the project is done, you can fondly remember the time you spent together working on it.

- Always prep your surface by sanding it, and don't forget to wipe it clean after. Sanding lightly to rough up your surface ensures that your paint has something to stick to.

- Add a coat of primer. Primer not only gives your paint a longer life, but it also ensures that you get better paint coverage. If you are painting something like an Ikea piece made of particleboard, you'll need a shellac-based primer (like BIN primer) to ensure that your paint sticks.

- Make a color sample. When it comes to choosing a paint color, pick up a paint sample and some thick artist paper (like watercolor or mixed-media paper) and make a color sample. Hang the sample in the space and see how the color looks in the light and how it changes throughout the day.

Continued...

- Apply the paint. You can either roll, spray, or brush the paint on your surface. Spraying will give you the fewest brushstrokes and help you get into any detailed areas more easily. You will most likely need to apply at least two coats of paint, with a third coat for minor touch-ups.

- Seal your work. After the paint has dried for at least a day, apply a protective finish topcoat sealer like Polycrylic. This ensures that your paint will last, be easier to clean, and stand up against wear and tear.

Since painting a piece of furniture can be controversial (at least in the comments section on the internet, where someone always claims the piece looked better before painting), if your piece is made of wood, you could also explore different colored stains! There are so many shades available (think: blues, greens, pinks!); you don't have to settle for brown. Follow the same steps to prep and seal your surface to ensure the longevity of your work.

You can also paint fabric- and leather-based furniture now. Keep your eyes peeled for specialty paints that expand the possibilities.

2. Don't match.

Instead of purchasing a classic dining room set complete with table and matching chairs, consider buying the items separately. Even if you don't go for a bold, colorful option, buying chairs separate from your dining table allows you to pull in different colors and textures to give the set a unique feel.

This approach also gives you shopping flexibility: You won't be forced into buying a set you really don't love. Stores often sell pieces separately, so you could buy your table from one store and your chairs from another. Get playful with color and shapes.

You'll also be able to swap out just the table or just the chairs in the future if you want to refresh the space without having to replace everything.

I suggest starting with your table. Will it be solid wood, glass, metal? Does your space require the shape to be oval, rectangular, or square with a leaf? Once you have these details figured out, you'll have a better idea of the number of chairs you'll need to fill the table.

If you want a classic tabletop but still want to add a special pop of color, consider looking for a colorful base or a table with changeable legs.

Chair Selection Tips

Be sure the chairs will fit your table. Here are some helpful tips to keep in mind as you make your selection:

- You want at least a foot of space between the top of the table and the chair seat for leg room. It's important that your chairs don't sit too low or too high. If you'll be using different chairs for every space at the table, be sure they all have the same seat height.

- Invest in mismatched chairs! Some manufacturers make the same chairs in different colors. Or you could easily paint wooden chairs to create your own mismatched set.

- Or get different chairs in the same color (this is an option for those thrifted chairs you want to paint). You could even do a combo of both. If you don't want every chair to be different, you could have matching side chairs with different chairs at the head and foot of the table.

There are so many ways to arrive at your own personal dining set, so don't feel like you need to stick to what's available. If the color of your chairs goes with the color palette of the room, they shouldn't feel out of place. The set could even be the brightest and most colorful choice in your home and feel like a collective statement piece.

3. **Cover it.**

Give your fabric-based furniture new life with a slipcover or by having it reupholstered. Before throwing out the pieces you already have, change them up with a bit of new fabric. You can now buy slipcovers for certain sofas; usually, the bigger the store, the better the options (try Ikea and Pottery Barn). You can also try to reupholster a piece yourself (but if it's more intricate, contact an upholsterer in your area to get a quote). While a custom slipcover can be pricey, it is oftentimes cheaper than buying a new sofa entirely, and a cool option because you get to choose your own fabric, which could be a fun pattern or exactly the shade you want.

4. **Add a rug.**

Rugs can make all the difference! They bring in color that you might not otherwise have in your furniture, and they can change the way a room feels. Light-colored rugs will make a room appear bigger, whereas a darker-toned rug might make it feel cozier and more grounded. If you don't like the color of your floors, using a large rug to cover as much square footage as possible is a smart way to change the color palette of a room.

The size of a rug really does matter in how well it can tie a room together. Ensure that yours is longer than your couch, allowing eight to twelve inches on either side. If the rug isn't large enough to have your furniture rest on top, then be sure that at least the front legs can rest on the rug. Rugs give you an opportunity to play with pattern and color in the room, so have fun with it!

5. Style it out.

Last but not least, styling a piece of furniture can change both its color and vibe. Think of a plain brown coffee table—when you stack some colorful books on top, it can suddenly be a bright spot in the room. The same goes for adding accent pillows. Sure, it's not technically changing a piece of furniture, but it is an easy way to mix things up and give your space a different feel. A pillow swap is especially nice to do when the seasons change to freshen up your main seating area. Don't be afraid to get several pillows (but not so many that you can no longer use the piece of furniture). Make them bold, go for a pattern, and bring new interest to a piece that you might not be able to fix up just yet.

Don't Forget the Outdoors

Outdoor furniture is a great place to really push yourself with color, because you use it less often and you don't have to bring every guest that visits outside; it can be a place just for you.

Start with brightly colored outdoor furniture (think: rugs, couches, pillows, tables, chairs, umbrellas, and so on). Then consider painting the cement or bringing in temporary outdoor tile. Faux grass is a nice way to cover up a cement floor or wall, especially in urban areas. If you have a wooden deck, there are all manner of colorful stains now available. Paint the picnic table a flashy color and create a bright oasis where you can enjoy a breath of fresh air. Just remember to use outdoor paint if you are giving anything a makeover.

Color versus Durability

Before buying anything new, think about how the piece will age in your home. Wear and tear is more obvious with some colors than with others. While white can be beautiful, it gets dirty fast, so consider who uses the space and what for. If you go for white, make sure you get a durable fabric that is cleanable. You may also want to consider a slightly off-white shade for an extra layer of protection. If you have pets, you probably already know that their hair is more likely to show on dark colors. This same reasoning also goes for dust on dark flooring. If you don't mind cleaning frequently, then carry on. But a mid-tone color might make your room feel cleaner.

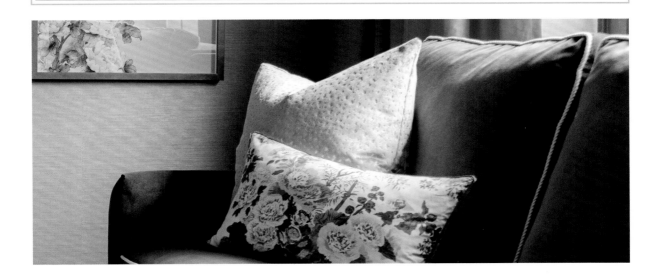

LET'S TALK ABOUT YOUR WALLS

One of the most memorable rooms I've ever lived in was my childhood bedroom. In high school, my dad let me paint my room any color I wanted. The freedom in that moment was liberating, especially as a teenager. I went all out. I chose four different colors, one for each wall: yellow, bright blue, neon green (yes, neon), and orange. It is absolutely a look I wouldn't pick today, but at the time I thought it was the best color combo that ever existed.

Did I come to regret living in a bedroom with bright, multicolored walls? Yes and no. I was only in the space a short amount of time before I graduated and moved out, so the initial fun didn't have the time to wear off. Did I find myself overstimulated from time to time because of all that intense color? Sure. But that could also have been because I had leopard-print bedding at the time as well. There really was not a moment of calm to be found in that room, which I can't say was the best approach to home décor—but I loved it and that's important.

The beauty of paint is that you can always paint over it when you need a change (a big thank-you to my dad for painting over those four colorful walls for me). When it comes to adding color through paint, it's helpful to remember that nothing is permanent.

So many people tell me they don't want to paint because it could affect the resale value of their home. But if that's the reason, then you're living in the next owner's home—not your own. Shake those ideas loose and live in your home for yourself and not for anyone else. Your home is your one space in this world where you can be yourself. Worry about the resale value when that time comes.

If you are a renter and nervous about your security deposit, don't fret. There are temporary solutions. And you can always offer to paint the walls back to their original color or ask your landlord what it would cost to have them repainted and pay to have it done when you move out.

I hope this pep talk has made you ready to add color to your walls! There is no one-size-fits-all rule when it comes to selecting paint. Every room, every home, and every person is different. That said, here is some general advice to consider before you plunge in.

Choosing Color

In terms of impact per cost, painting really is one of the best and quickest ways to add color to your home. If you're still working on your home's color palette, always, always, always start with the function of a room to help you narrow down your colors. If you have a hard time sleeping and you're going to paint your bedroom, perhaps neon pink is not the best direction to go in, no matter how much you like the color. You could still make that one of your accents if you really want it in the room, but coating your walls with it will definitely create an energetic space that might not

help you get to sleep any faster. But let's say you have an easy time going to sleep but need some extra pep in the morning to get going. You could lean into energizing colors like yellow (or that neon pink). Considering your needs and habits when picking a paint is a good starting point.

Also consider where your home is located when trying to decide what colors to bring inside. For example, if you live in a large metropolitan area, you might be surrounded by gray concrete. Instead of bringing even more gray to your space, try green or another earth tone that resembles a park or garden to create your own sanctuary, like a décor juxtaposition to what you see when you leave. Similarly, if you live in the woods, you might want to bring in the colors that you don't see on a daily basis to give yourself balance.

The size of your home and the space you're painting can also determine color. Light colors on the wall will make a space feel larger than it is, so if your house is small and you want to open it up, I suggest looking at lighter hues of your favorite color. If you want to create a cozy, more intimate feeling, opt for a color with more saturation.

Choose any of the main, secondary, or neutral colors from your color palette, but keep in mind how dominant the color will be. If navy blue is one of your accent colors, you wouldn't want to apply it to every wall in a room because then it would become the main color (from surface area alone). Instead, add navy blue in smaller areas like the trim or even a door.

Consider Custom Paint

Let's say you're browsing the paint chip section at the hardware store and you can't quite find the shade you want for your space. Maybe the undertones are too cool or too warm, or something else about it isn't right. Well, the good news is that you don't have to settle! Some hardware stores offer custom matching from other brands' paint chips, photos, or even physical objects (call before going in to be sure your store offers this service). Pull a color from the wallpaper you're using in a room, or maybe a décor accent piece. This expands your selection far beyond the samples in the store and gives you the opportunity to bring home your favorite shade.

Before You Paint

Always get a test color. I know it's tempting to go to the paint store, pick out a color, and get to work. But trust me, I've done this several times, so please learn from my mistakes. The main reason it's better to be patient and give yourself time to prep is that your home and the hardware store have different lighting conditions.

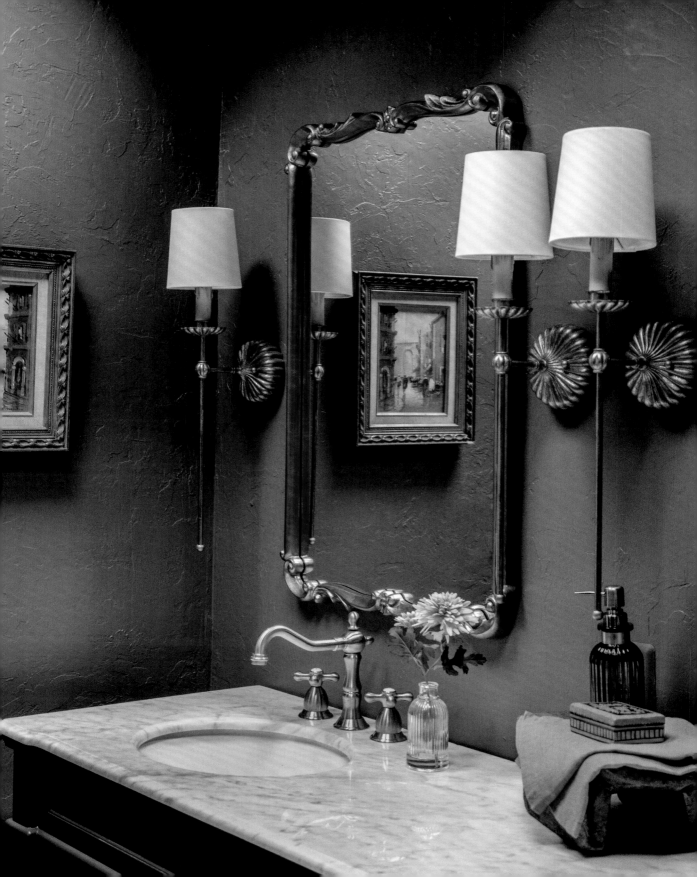

A color may look incredible in the store but have an entirely different vibe in your home. Remember that color doesn't exist in a vacuum, so while the paint chip might be the perfect color, it will be changed by the lighting, flooring, fixtures, and textiles that surround it.

It's always, always, always better to get a test batch before you commit. Most stores sell small sample containers for under ten dollars. Do yourself a favor and have a few sample colors mixed before you commit to one. You can either paint the sample color directly on the wall you're considering or, my personal favorite option, paint on a piece of thick watercolor paper and tape that to the wall. (Some stores also sell peel-and-stick sheets that you can adhere to the wall, but using paper is probably a little less expensive.) With sheets of paper, you can move your sample around the room to see how it looks under different lighting conditions. You can also test a larger area of the wall without worrying about painting over it later if you go in a different color direction.

If you're really crunched for time and don't want to deal with painting samples, at least grab multiples of the same swatch (at least six), tape them together, and hang them on the wall. The slightly larger area of color will give you a better idea of how it will look in the space (versus just using one tiny sample) and you can move it around the room as above.

A good rule of thumb is that it's better to spend a little more time and money to do a project right than to rush and be forced to redo the entire thing later.

Six Ways to Add Color to Your Walls

Now that I've got you geared up to paint everything in your house, here are some ways to add color to your walls, whether you just want to dip your toe in as a renter or go all out.

1. Pin it up.

If you're not ready to paint, you can still add some color to your walls. Hang a pegboard or an oversize cork board (from floor to ceiling) so you can pin up your colorful inspiration images. You could even paint the cork, whether that's the entire board or a fun pattern or shape on the background. This gives you color and warmth on the walls without having to commit to painting or any one color. Installation will probably require a little bit of drilling, but you'll be able to swap color in and out on a regular basis without creating any additional damage or work.

2. **Make it temporary.**

Removable vinyl and peel-and-stick wallpapers are perfect to use in spaces that you aren't ready or able to paint. Think of these options like big stickers. You can apply them to the entire room or use them strategically to create an accent wall or point of interest. If you're feeling nervous about getting your deposit back, it never hurts to do a test swatch before committing.

Keep the texture of your walls in mind. If they're rough, the texture could show through the vinyl or even be damaged upon removal. Textured walls also make it significantly more difficult to line up a pattern in removable wallpaper, so keep the pattern simple. Try applying a small piece (in a non-obvious spot), leave it up for a few days, and then remove it. If the wall looks okay, you should be good to go.

3. **Paint small.**

If you're ready to put that paintbrush to use, start small by just painting the trim. The trim of your door (the part that's hidden when it's closed) is a great little secret place to add a pop of color. You could also extend this idea to the actual trim around the door, or to your baseboards. Leaving the walls white or neutral (as they most likely are when you move in) and adding that small pop of color will make a big impression without a ton of effort or commitment.

4. Do a wall.

If you are craving more after you've done the trim, try your hand at creating an accent wall. There's nothing written that says if you paint your walls, you need to paint every square inch of them. In fact, paint can really have an impact when it's used in a smaller way. Paint just one wall. Paint a large shape on the wall. Paint a mural. Paint a pattern. There's no shortage of ways to add color that don't involve painting all four walls.

5. Look up.

Still looking for more? Don't forget the ceiling! You can think of it as the fifth wall. It might be more work, especially since you'll have to be on a ladder looking up while you work, but the ceiling is also fair game when it comes to color. You can even wallpaper the ceiling for a boost of pattern. Alternatively, if you don't want to paint your walls but still want to bring intrigue to the space, you can just apply color to the ceiling.

6. Go big.

And for the maximalist, paint it all: the trim, the wall, the door, the ceiling. All of it! The style is called color drenching because it's exactly how it sounds. Painting everything the same color will really enclose you in the color. It's not for the faint of heart, but again, the motto when painting is that nothing is permanent.

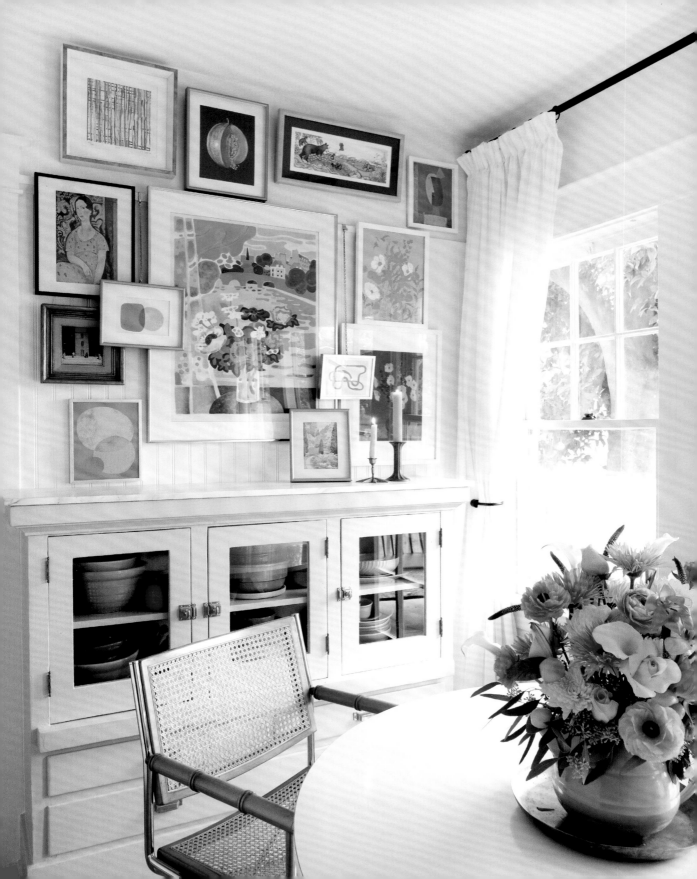

Chapter 6

CURATING YOUR OWN ART GALLERY

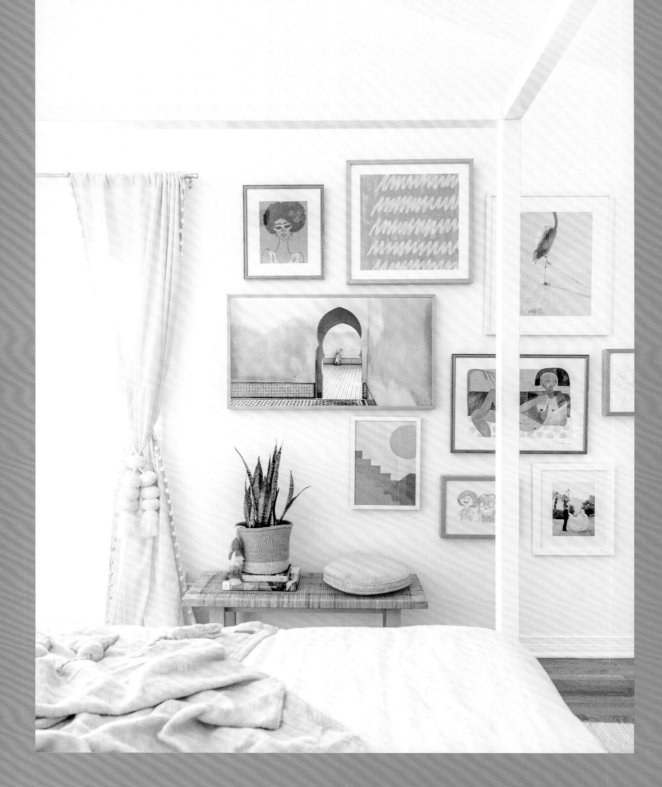

One of the quickest ways to change the mood of a space is by adding or changing your art. Art may be more impactful than changing your furniture, for instance, because it is often placed at a focal point in the room and displayed at eye level. (If you've ever wondered where on the wall to hang your art, it's at eye level!) Given that art is often the first thing you notice when you walk into a home, adding paintings, photography, sculptures, and more is a perfect way to reinforce your color story and share more about your personality.

Color absolutely plays a hand in the overall mood of a space because it is directly linked to how art can make us feel. Dark and moody pieces give a space a cozy and intimate feel, whereas bright neons and bolds make a room feel alive and energetic. What colors make you feel calm or creative or sleepy or happy? We'll get into how to add color to your art in the coming pages, but it's helpful to keep the function of the room in mind while deciding where you'd like to display your art.

Art can also showcase an aspect of your interests. It is the perfect opportunity to let your personality come through and add a bit of soul to your home. Not to be cliché, but decorating with art really is a great way to turn your house into a home. That's a lot of weight for a piece of home décor to carry, but instead of being overwhelmed by the idea, I hope you lean into the fun.

Art can be funny, it can be a conversation starter, it can be beautiful, it can be ugly. Art can be a reminder of a family moment or happy memory, or it can be entirely abstract. You just need to decide what you want for your space and go for it—because like color, art is completely subjective. While I can guide you with tips and tricks for finding art, adding color to existing pieces, and displaying it in your home, at the end of the day, the art you choose should always be for yourself and the people who share your home. Remember, you and your family or roommates are the ones seeing it on a daily basis, and it should bring you all joy.

You don't need to spend a ton of money to have a beautiful art collection. In fact, there are so many options between mass-produced art and one-of-a-kind million-dollar pieces. You can easily fill your home with unique finds on any budget. From family pictures, photographs, and paintings to thrifted and vintage finds, there are several different types of art for your walls. I hope the next few pages help you figure out how to display your art in colorful ways that fit your home.

"Your home should tell the story of who you are, and be a collection of what you love."

———

NATE BERKUS

Four Ways to Add Color Through Art

Think of your walls like a fun art gallery. What art do you love to see in person? What kind of art makes you pause when you walk by it? Has a piece of art ever stopped you in your tracks? And what's stopping you from having the same experience in your own home?

Because a blank wall feels incomplete, having one is almost like an itch we need to immediately scratch when moving into a new space. But when you shift your décor thinking from "I need to fill this empty space" to "What will I enjoy looking at on a daily basis?" you'll start to discover what type of art you prefer.

Treating your walls like a gallery space also gives you permission to bring in as much color as you like. You get to be the curator of your own space and can set the mood or color palette to anything that you personally enjoy. Remember that, just as a gallery changes pieces out, you can change things up as your taste evolves or you find new pieces. This is especially true if you find items of a similar size, which makes it easy for you to swap pieces in and out when you want to refresh your space or bring in seasonal colors.

When looking for art for your home, you want the colors to coordinate either with each other (if you're building a gallery wall) or the room itself. But sticking to your color palette doesn't have to be as rigid for art as for the wall color or furniture choice. There's flexibility because there are several ways in which a piece can coordinate with its surroundings. Either the art, the frame, or the mat should be close to your chosen color palette to give it a sense of cohesion. Whether you're just starting an art collection of your own or you've had pieces around for years and are looking for a bit of a refresh, here are four ways to add color through art:

1. Colorful art.

A colorful painting, print, poster, or photograph is without a doubt the easiest way to add color to your walls. Think outside of the classic art print or canvas style and frame a meaningful keepsake like a matchbook collection or cork from a special bottle of champagne; anything three-dimensional is fair game if it fits inside a shadow box frame. If you already have pieces that fit your home's color palette, amazing! You can skip to the next step to see how to take the art up a few notches with even more color.

If you're just building your collection, then this is the fun part. Hunting for great art takes time and patience, but it can also be the most memorable experience. For example, my husband and I stumbled into a thrift store in Rome while on our honeymoon and found an original painting of Naples from 1967 for only eleven euros. We bought it, but when we got back to the hotel, we realized it wouldn't fit into our suitcases. That had us going all over the city looking for someone to help us take the painting out of the frame for the journey home. By the time we had to leave for our next destination, we still hadn't found that person, so the painting came on the train with us and sat on my lap the entire time. Finally, two cities later, the concierge at our hotel connected us with their mother, who was a professional framer and knew exactly how to free the painting without damaging the art or the frame. We now have the painting hanging at home and will never forget the story attached to it.

All of this is to say: Go out of your way for the pieces you really love. Invest in art that makes you feel something, was made by a local artist, or you found while traveling. With as much power as art can have, I want to push you to explore more than your typical home décor stores. While the art that you find in stores like HomeGoods, Target, or Ikea might be beautiful, it is mass-produced

1967 NAPLES PAINTING

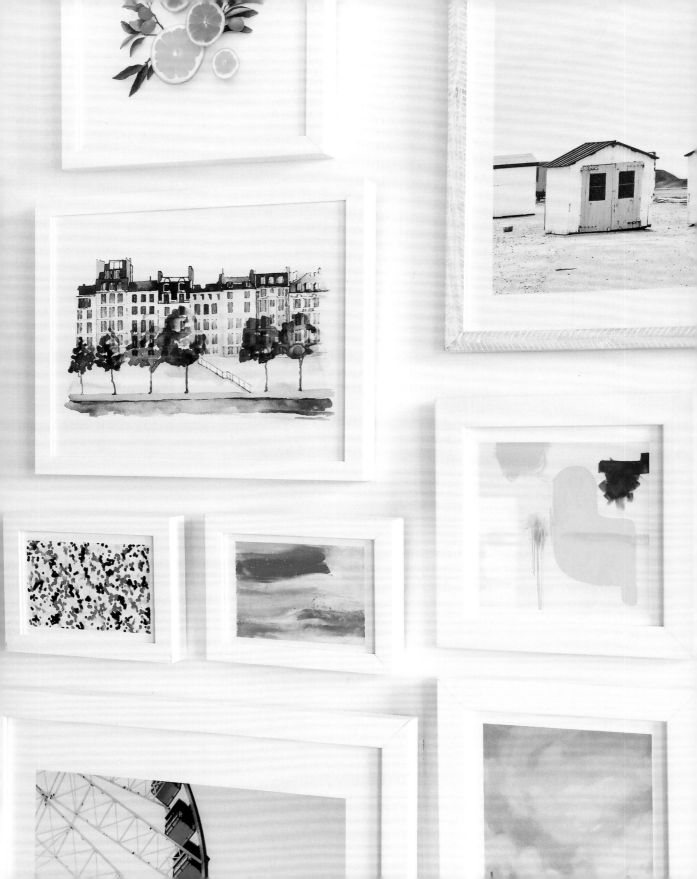

in the hopes of selling as many pieces as possible. You deserve something unique that's personal and connected to you and your story. You deserve art in your home that makes you feel the way those pieces that stopped you in your tracks made you feel, regardless of your budget. It is your home, after all. So don't feel like you must fill your walls just because they're blank—it's okay to wait for the piece that you are willing to carry with you through any inconveniences.

Some things to keep in mind: The larger the art is, the bigger impact it will make. I like to have either one large piece that fills an entire blank space of a wall, sets of two or three pieces that complement each other's color palettes and can be hung side by side, or, of course, a gallery wall. A gallery wall might take more time to come together, but it allows you to explore a color palette and build with multiple colors. You may end up collecting art for all three of these suggested setups because you likely have more than one wall to fill. There are also smaller nooks where one piece of art can stand alone (think: on a bookshelf or hanging in the bathroom).

If the art you currently have isn't as colorful as you want or in your new color palette but you still love it, don't worry! There are other ways to bring your chosen colors to those pieces and make them feel cohesive.

DIY Art

Looking for some ways to make your own art?

- Go abstract and apply paint to a canvas. Pick three to five colors from your color palette. Use different brushstrokes, paint splatters, or shapes to get you started—or even use your hands. If other people live in your home, consider working on this project together. You can all paint one canvas or each person can do their own as companion pieces to yours.

- Have your photographs enlarged as engineer prints to frame and hang. Staples or another office supply store can do this for a fraction of the cost to print photographs at that scale. The paper is thin like printer paper, but it has a nice matte finish, and once the prints are framed they have a professional look.

- Did you know that many works from your favorite museums around the world are in the public domain? That means you can print copies to display in your home for free! The Metropolitan Museum in New York alone has more than 492,000 images in their collection. Simply search for open access images and browse the collection at any museum, all from the comfort of your home. If you want to give the work a more painterly feel, apply one to two coats of matte Mod Podge on top, working your brushstrokes in a similar direction to the painting.

- Use leftover peel-and-stick wallpaper scraps to make instant art. Apply it to a piece of paper (or use the paper that already comes with your frame). Hang your piece on the same wallpapered wall, lining up the pattern for a bit of whimsical pattern play.

2. The frame!

Adding not-so-colorful art to a colorful frame can help punch up your piece. You can't go wrong with a frame in your home's color palette. Whether you're working with a professional framer or picking something out yourself at a store, frames have come a long way in terms of variety and affordability. If you can't find a frame in your desired color, you can always spray paint the frame (just be sure to prime and seal it to make the paint last longer). Searching out discounted frames or thrifting are both ways to save a little cash and experiment with colors.

It's also worth exploring nontraditional framing options like picture hangers, non-rectangular frames, acrylic displays, and more. If you're framing two pieces side by side or making a perfect grid gallery wall, using the same frame for your pieces gives you a stronger sense of unity. But outside of these situations, feel free to mix and match your frames! Use different colors and textures to add a layer of intrigue. When you bring it back to your home's color palette, everything will match without having to match exactly.

Places to Source Art

ANTIQUE MALLS + FLEA MARKETS: While you can still thrift your art, I find that antique malls often have a better selection. The pieces tend to be original paintings or unique prints. Focus on the art and don't let an ugly frame discourage you from loving a piece. You can always reframe it!

LOCAL CRAFT + ART FAIRS: These are such a terrific way to support artists in your area. You might find original pieces here as well as prints.

ETSY: This huge online store is a good source for vintage art but also current artists. Just search for the subject matter or even colors of paintings you like and browse away. I find it helpful to "like" every piece I'm considering and then go back after browsing to narrow down my selections. You can even search for downloadable art if you want to print something ASAP at home yourself.

SOCIETY6: This online shop has a wide selection of affordable prints that the artists have uploaded themselves. If you find an artist you like, don't be afraid to follow them to see if they ever sell originals as well.

3. **The mat!**

One of my favorite reasons to add a mat to a frame is to increase the overall size of the art. Let's say the art you really want to hang is too small for the space. Adding a mat means you can get a larger frame and, thus, fill up more wall space. So even if the piece

you have is five by seven inches, the framer can add a mat to bump it up to eight by ten inches or even larger, depending on how much space you need to fill.

Mats don't have to be white or black—they can be patterned, have bold colors, or even be multicolored. If you're still having trouble finding the exact color you want, there's always a DIY solution. Add pattern by affixing wallpaper or decoupage paper. Paint it to add art to your art! Or use a mat cutter (made specifically for this purpose) and mat board from the art supply store to make your own in whatever size and shape you like.

Another trick is to layer your mats on your art, bringing in at least two different colors to surround it.

4. **Even more color.**

If, after the art, the frame, and the mat, you STILL want to add more color to your art, extend the color of the frame to the wall itself. This can be as simple as painting a rectangle behind a rectangular frame or cutting out fun shapes like scallops or circles from removable vinyl and making a wall design.

Let's say your art is hanging in an eight-by-ten-inch black frame and your color palette is black and white with neutral accents. Consider adding a black rectangle or circle (that's at least twelve by fourteen inches) to your wall where the art will hang. This technique turns a simple piece into a statement. If you're worried about how it will look, try it first on a smaller scale using removable vinyl.

To leave your walls alone but still make a colorful impact, hang a gallery wall. If you want the ability to change things up more often, install a picture railing or shelf. This lets you move your art around easily without putting new holes in the wall.

Remember to display art that makes you feel happy. And don't forget to follow that feeling of joy as you hunt for art; it will help you decide what looks best in your home.

Chapter 7

EMPHASIZING
ACCENTS

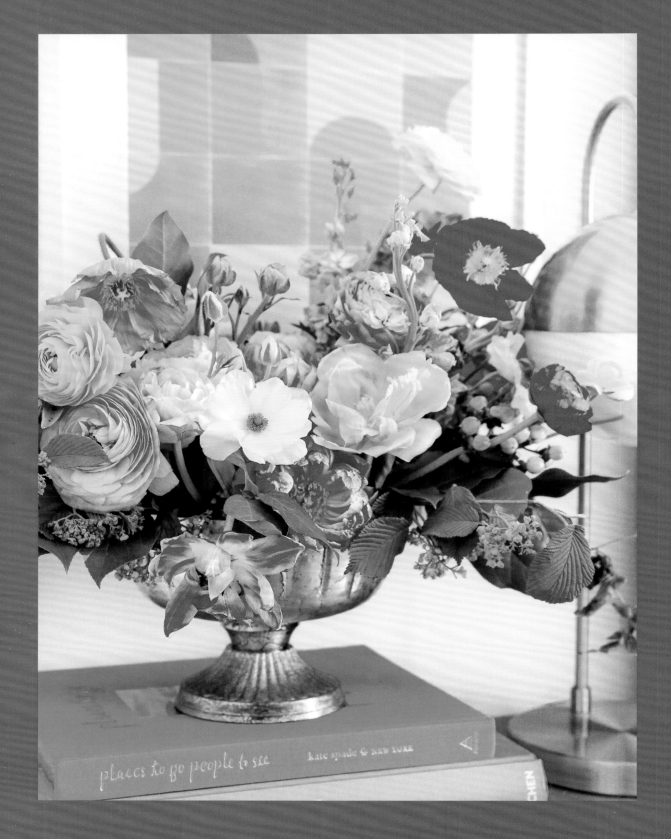

places to go people to see kate spade ♥ new york

*S*ometimes small tweaks can have the biggest impact in a space, especially when it comes to bringing in color. There are so many simple changes you can make around your home that won't take all day to complete or cost you an arm and a leg to purchase. Let's say you want to infuse a bit of color into your space but don't want to update your furniture or paint your walls just yet. Saving money and waiting for the right time to make major changes is important, but you shouldn't have to live without color until then.

More often than not, it's easier to work with what you have and build your way up to a more colorful space over time. Not only will that give you time to be thoughtful with your purchases and your color palette, but it will also help you be intentional with color instead of just trying to finish decorating a space for the sake of having it complete.

Accent pieces help you embellish the practical aspects of your home and give you an opportunity to let your personality shine. Because these pieces aren't the focal point of the room (thus the term *accent*), you have freedom to go for fun and enjoyment when choosing them. They also help you reinforce the secondary colors from your color palette. In short, accents help you jump right into decorating with color in a painless way.

So what do I consider a home décor accent to be? Common pieces include lamps, 3-D art pieces like sculptures, decorative items like trays, boxes, baskets, vases, and planters, as well as decorative bowls, candles, clocks, and much, much more. Think of fun and funky pieces—anything you picked up while traveling, flea market finds, crafts, and even family heirlooms. While these pieces can be functional (like a lamp or clock), they can also be cool accessories and conversation starters. In fact, think of décor accents like you would fashion accessories such as jewelry, belts, and bags. Each has the ability to tie a room together—the way a statement necklace makes an outfit—and, when used correctly, can make your entire space feel unique.

You can be really playful with accent pieces and, because they aren't heavy anchors in a space, you can swap them in and out or move them around your home as you like. Unlike a couch or dining room table, home décor accents tend to be more affordable. These are simple changes you can make throughout your house that tie your colors together. You don't have to worry about doing a complete room makeover or investing a lot of money; sometimes an impactful change can be as easy as adding small details: a new candleholder, a hanging plant, a vase of fresh flowers. If you're feeling a bit nervous about really committing to color, don't worry. You can start slow and wherever you feel comfortable. Avoid the stress and the pressure and just have fun on your colorful home journey.

Easy Ways to Add Color to Your Home Décor

Here are a few quick changes you can make within your home that will add lovely colorful pops to your day and tide you over until you're able to move forward with higher-impact color swaps:

1. Swap small accents.

Think: a doormat, a soap dispenser, or the towel hanging on the front of your stove. They're utilitarian, but that doesn't mean they can't feel special or bring you joy. These are some of the pieces I suggest you swap out first because you encounter them so frequently. Opting for colorful versions will bring a little moment of joy even when you're doing the dishes.

2. Cover your pillows.

What's nice about accent pillows is that you only need to swap out the covers to make a change. Switch the colors seasonally or anytime you feel like adjusting a room's vibe. When buying accent pillows for your couch or bed, buy ones with zippered covers to give you flexibility. And you can always buy (or make) new zippered covers that fit over pillows that don't have removable covers.

3. Treat your windows.

Curtains and shades are fun places to add little pops of color. Use a neutral shade with a colorful pattern detail, look for curtains with a fringe or a dip-dyed look, or go all out on full-color curtains.

If you go the full-color route, keep in mind the amount of sunlight the room receives. I once hung pink curtains in a living room that got afternoon light. During the brightest part of the day, when I kept the curtains closed, everything in the room took on a pink glow. While seeing through a pink filter sounds fun in theory, if it's not what you were going for, the effect could be unwelcome.

4. Add a bold rug.

Yes, a rug can be a large decorative element, but it's also an easy place to play around with boldness. Because rugs are usually placed under furniture, only a section of it shows. Even if your furniture is neutral, a rug can bring in color without overwhelming a space simply because of its placement.

5. Build a collection.

Anything that you store in a closed cabinet can be wildly colorful without affecting the rest of your home. Your dishes, for instance, can be your all-time favorite, boldest color even if the rest of your home isn't because they don't sit out in the open and you and your guests only use them temporarily. If you have open shelving for storage, you might want to reconsider this idea, but for the most part, if it's stored behind a door, you can go as wild as you want.

6. Color a hidden space.

The inside of your cabinets is another cool place to go bold. Again, when the doors are closed, your home aesthetic remains the same, so you don't have to worry about changing the rest of the room to

match. You can go as bright as you want, and it'll be a hidden secret that brings you joy whenever you access the cabinets. This idea works for painting kitchen cabinets, but you can also apply this to any closet or cabinet in the house—even a utility closet.

Are there other hidden places to bring in color? What about the lining of your fridge drawers or inside your TV cabinet? One place I love to add color is the sides of my dresser drawers. When the drawers are closed, they look normal, but when I slide open a drawer, I get a surprise pop of color. Removable wallpaper is a good option here.

7. Tape the door trim.

If you rent your place or just want to test out the idea of painting your door trim a specific color, use washi tape to tape around the inside part of the door frame that isn't visible when the door is closed or the trim around the outside of the door. Washi tape won't leave any residue and it's relatively easy to apply. The only downside is that it is temporary, and you might need to replace it with use. An upside is that you can play around with patterns and swap the tape out when you want to try a new color.

8. Swap your light switch covers.

My first instinct as a crafter is to tell you to get creative with the ones you already have, whether that's applying vinyl or just investing a bit of time and paint. When painting a light switch cover, especially if it's plastic, clean and prep the surface, then prime, paint, and seal (spray paint works well here). Because light switch covers are highly used items and you want the paint to last, don't skip any steps. You could paint the cover a solid color to match your palette or make it pop as a statement color (think red on a white wall or coral on a blue wall). Or use the same color as your wall color to make the covers blend in. Don't forget to paint the screws as well for a more seamless look.

You can also swap out the covers for new ones if you're looking for a different style, more detail, or something that better complements your space. It's always a smart idea to paint what you have first to see how a new colorful plate looks, and then invest from there when you find what you're looking for.

METALLIC LIGHT SWITCH COVER PAINTED LIGHT SWITCH COVER

9. Change your lampshade!

Maybe you choose a different color or one with a pattern, but changing the shade can give any lamp an entirely different look. If you stick with neutral colors, pick a lamp base with an unusual shape or details to give it visual interest. You could even dye a white shade to save a bit of money and get the custom color you want. Quick note: Colorful lampshades work best for side or end tables because they let less light into the room compared to a light-colored shade. If you want the lighting in a room to be moody versus bright, put a colored shade on a floor lamp.

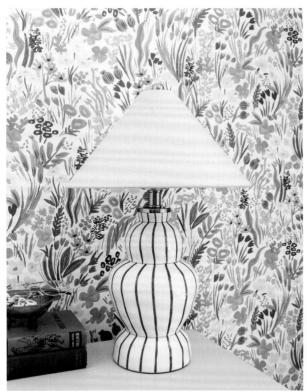

LAMPSHADE BEFORE

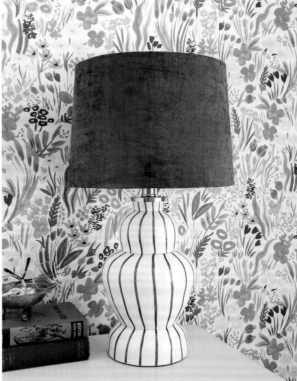

LAMPSHADE AFTER

10. Update your hardware.

Nowadays you can find colored door-knobs, drawer pulls, cabinet handles, coat hooks, and so on. Hardware tends to be metal, so consider how your particular finish looks with your new color palette. Switch from silver to brass or copper if you want a warmer look. Or explore colorful options by looking for enamel or glass. Changing out the hardware gives a piece of furniture or even your kitchen cabinets a spruce-up without a big investment in time or effort. This is a good option for renters, because even though you're investing money in your apartment, you can take the hardware with you when you leave. (Be sure to keep the old hardware so you can swap it back before you move out.)

11. Organize books by color.

Make an inventory of your books and note the main colors. See how they play into your color palette and then organize them accordingly. ROYGBIV is a popular way to display books on a shelf, but you can arrange your color groupings in any order. Maybe you prefer a sunset-on-the-water look or want to alternate between warm and cool colors. If you have a large book collection, consider organizing by color within each genre so you know when one stops

and another begins. You'll be surprised to see how quickly you're able to find the book you're looking for when you can recall the color of the book cover or spine instead of trying to remember the two books you stored it between.

Don't have a lot of books? Try styling a small color story on a shelf and bring in an extra pop of color with bookends. Think of bookends as functional art sculptures and choose ones that reflect your personality or interests to make the styling unique. And if you really want to dedicate yourself to a specific color palette, create your own book cover sleeves by wrapping your books with paper. This might take a very long time and isn't something I necessarily suggest if your collection is massive, but if your books are a center-piece of your home, think of this idea as another way to drive home a color story by using what you already have.

If you're a neutrals lover, you could try turning your books the other way around so the pages are visible instead of the colorful spines. This makes a space minimalist in nature because there's no text or additional colors for distraction. This might work best when applied to a small stack; otherwise you could end up spending more time than you'd like searching for the book you need.

12. **Revisit your art.**

We talked about art in the previous chapter, but here's another reminder that art can extend past the frame. Think sculpture or decorative carvings. If you have just one or a few items to display (rather than a whole collection or a gallery wall), your art can be as funky and fun as you like. When pairing ornate pieces (think: a lot of pattern or bold coloring), match them with more minimalist accents for balance. Or if you find a piece that's neutral in color, add interest through the texture or shape.

Decorate with Plants and Flowers

Adding live foliage and cut flowers to your home not only brings in color and texture, but also adds life and warmth to your space. You don't have to have a green thumb or even spend a lot of money to enjoy them, either. Aside from being beautiful and colorful, plants have health benefits too. According to the National Library of Medicine, interaction with indoor plants may reduce psychological and physiological stress by suppressing autonomic nervous system activity, which is tied to your heart rate and blood pressure. Add that to your list of reasons to remember to water your plants!

Additionally, certain plants, such as spider plants and rubber trees, can reduce indoor air pollutants, even if at a slow rate. You don't have to turn your living room into a jungle to get the positive effects of a house plant (though I also fully support that idea). Bringing a plant inside is an easy way to enjoy nature even if you don't happen to have access to an outdoor area or need a pick-me-up during winter and gray rainy days. Start with one easy-to-grow type and expand as you learn proper care. When adding plants to your home, be mindful that certain ones might be hazardous to your pets or young children.

You might be thinking, *I just made the color palette for my home and green is not in it.* But remember, the idea is to be intentional with color above everything else. So if you want a plant, bring in the life, bring in the color! If you want it to blend with your home, focus your color match on the planter or container you display it in. The leaves get a pass, especially when you think of all the benefits plants bring.

The other thing? Plants come in many different shades of green and even non-green options if you want something a little different. You'll find pinks and reds in the prayer plant, spiderwort,

or pink splash caladium, and there are even polka-dotted plants like the begonia maculata. Consider visiting a greenhouse, your local nursery, or an online shop to explore new plants. More than likely, you'll end up with a green plant, but that doesn't mean you can't shop around for a pot in your favorite complementary color or paint yours to match your home.

If you can't remember to water your plants, take that into consideration when deciding which ones to bring home. Starter plants, like philodendrons, can be found at most major hardware stores and even select home stores. They get droopy if you forget to water them, but they usually brighten right back up when you give them a drink. Snake and pothos plants are also good low-light and low-water options. Know your strengths as well as your weaknesses before making any purchases. It's also helpful to have a set day of the week be your watering day, so try to get plants that have similar needs so you aren't working overtime to keep up with a schedule.

Other Ways to Bring Plants Home

Plants aren't only decorative choices. Plant an herb garden for your kitchen to add a pop of greenery and grow a cooking ingredient you can use. Or forage for branches and greenery stems. This option brings in outside life, texture, and an earth tones color palette without you having to maintain a plant week after week.

Faux plants are another option to explore, but be particular about the type of faux plants you buy. To look authentic, you want the color of the greenery to be as close as possible to the actual plant color. Also, check for obvious seams in the stems; they can be a dead giveaway when it comes to spotting a fake.

A large faux tree option can be a nice filler of space, especially in a dark corner where you want some life but nothing will grow. Although there are several varieties out there, a few of my favorite faux trees are olive, ficus, or eucalyptus. To make your tree look as realistic as possible, don't skimp on the container. Fill the base with kraft paper and top it with rocks or decorative Spanish moss. This extra effort makes it look like the tree is planted instead of just sitting inside a container.

Flowers

From brights to pastels, neutrals to moody shades, there really isn't a color you can't find in a flower. Flowers also have the tendency to fade slowly in color as they age, meaning you can see so many different hues just in one bloom. Although fresh-cut flowers don't usually last more than a week, they're a lovely way of bringing a pop of color and joy into your home. And while we might sometimes wait until we're having guests over to justify their purchase, remember that you are also worthy of the same thoughtfulness.

Think of your favorite flower right now: Do you know if it grows in any other color? Some flowers, like tulips, come in a rainbow of colors and varieties. Daffodils are often associated with yellow, but they're much more complex in their coloring. They come in golden, bright yellow, pale yellow, pale orange, white, and more. Whatever your favorite flower might be, see if a variety comes in your favorite color as well.

The farmers' market in your area will likely have offerings for in-season and local flowers. Sometimes half the fun of visiting the market is taking note of the colors throughout the year and how they change depending on the season. If you live in a larger city, be sure to explore your flower district. Oftentimes these are whole-sale vendors that sell to professionals, but they might have public options too.

While grocery store flowers can certainly fill a flower void (and often for a reasonable price), if you're looking to expand your floral knowledge, I suggest visiting your local florist. They will have access to more uncommon varieties of flowers and can even order what you're looking for if you give them enough notice.

Don't have a favorite flower yet? One of the benefits of working with a local florist is that you can have a bouquet made just for you. Ask the florist to build a bouquet with your favorite colors and you might discover new flowers that could become your favorites. If you love fresh flowers, here's a money-saving tip: See if your local florist offers subscriptions. This is a way for you to have a standing order for blooms, often given at a discount because you commit to buying flowers regularly or for a seasonal time frame.

My main advice when it comes to fresh flowers is to enjoy them for the temporary color they offer. Take notice of how they change colors as they fade. Appreciate them for what they are and how long they last. Be inspired by the beauty they bring to the world before they go. The beauty of color is temporary sometimes.

If you don't want to spend money on fresh-cut blooms, one live flower option is the potted orchid. Orchids are a mix between a house plant and a flower, so you get the best of both worlds, and they come in many colors and sizes. Another option if you want your flowers to last longer than a week is to consider dried flowers. There are several bright options out there, so don't think dried florals necessarily means neutral tones.

One final fun option would be to plant your own flowers! Whether you dedicate yard space to having a flower garden or plant a few blooms in a container, growing your own flowers can be a rewarding way to bring color to the outside of your home before you bring the color inside.

Faux Flowers

Faux flowers are the perfect option for those of us who always want flowers in our homes. Like real flowers, faux flowers come in all different shapes, sizes, and colors. The materials they are made from can also vary, giving you another way to incorporate different textures in your home.

If your goal for your faux flowers is for them to resemble real flowers in color and shape, then you need to factor in quality when shopping around. The ones you might see at a dollar or craft store can read as artificial right away because they are mass-produced to be affordable. Ones that resemble the real deal are worth the investment when you consider that you'll display them in your home year-round versus buying a new bouquet every week. While they might cost more than a standard bouquet up front, you'll get years of wear out of them. Afloral.com is a great source for faux flowers. Small boutique home and gift stores also sell faux flowers at select times during the year. I personally like to mix faux and real flowers throughout my home (some of my vases contain faux flowers, while others have the real thing). If you have a lot of space to fill in your home, mixing faux and fresh flowers can be a nice option.

To add more color to a natural element, forage for some branches and then use hot glue to affix faux flowers as if it were a flowering branch. This gives you real texture without having to worry about watering.

Although handmade flowers may not look as real as a silk flower, they bring some whimsy to a space. You don't always have to choose flowers that pass for the real thing to enjoy them. Paper and crepe flowers can be fun!

Some tips for selecting good-quality faux flowers:

- Opt for high-quality materials. Silk is the top end, but you can find cotton and polyester alternatives. Any material that isn't only plastic should give you a more realistic feel and look.

- The color of the flowers should be close to the real deal. Many plastic flowers come in bright colors. And while bright colors can be fun, if you're trying to have a realistic look, then the faux version should mimic the true colors.

- Is there dimension to the petals? This could be through color or in the size of the flowers. Look for flowers that come in different sizes so when they are grouped together in a bouquet, it reads more natural. No two flowers are exactly alike, so your faux ones should have dimension as well.

- The stems and leaves should bend and move to create an organic arrangement. This flexibility will help you build a beautiful faux bouquet as well.

- If you really want your flowers to pass for real, keep the seasons in mind (for example, tulips only appear in the springtime, so if you have them in October, it's obvious that they're fake). Rotate different types throughout the year.

- Consider using a colorful vase versus one that's clear so as to not give away that there is no water in the container.

- Finally, don't forget to dust and protect them. Where you place them in your home will affect their longevity. Faux flowers in a bathroom with a shower might collect dust more easily due to the steam of the shower. In the kitchen, a bouquet close to the stove might pick up some grease. It's better to place your faux arrangements away from these elements, on coffee tables, shelves, the bedside, and so on.

From the temporary (like plants and flowers), to lifelong pieces, home décor accents can be approached with whimsy. They're a way to add a little spice, and a lot of joy, to any room. So have fun, embrace the funky, and don't be afraid to mix things up.

Decorate for the Holidays

Red and green. Black and orange. Red and pink. Gold and black. Red, white, and blue. Even without me telling you what those color combos are referencing, I bet you automatically think of a specific holiday. Holiday colors are so ingrained in society, that even when we all have different décor styles, the colors we use to decorate for the holidays tend to be the same.

For the most part, holiday colors can be traced back to older traditions and symbolism. For example, the black and orange of Halloween represent the night sky and the fire of harvest season. According to the *Farmer's Almanac*, the reds and greens we typically see during Christmastime began with the ancient Romans. People decorated their homes with candles, evergreens, and holly to celebrate Saturn, the god of agriculture and harvest. As time passed, the red and green of holly leaves and berries were absorbed into Christmas celebrations with the advent of Christianity.

Holidays are personal and we have strong memories attached to them; oftentimes, putting up decorations are some of our most cherished ones. If traditional colors make you feel nostalgic and heighten your enjoyment of the celebrations, then by all means keep them as part of your décor. But let me fill you in on a little secret: As lovely as holiday traditions may be, when it comes to décor, you don't have to use the same old color combinations. You don't have to stick to a particular color scheme because the ancient Romans chose it centuries ago.

You've already created a color palette for your home, so why not make one for holiday décor too? What's great about having a palette that you'll only use for a little while is that you're free to explore as many colors as you want. It's like a color free-for-all and one that you can create just for fun.

I love the idea of having classic holiday color combos as a base for my decoration and then using them as a jumping-off point to add my favorite colors along the way. But remember, you don't have to decorate with colors you don't like just because they're tied to a holiday.

For Valentine's Day, for example, if you like red and pink, start there, then maybe bring in a chocolatey brown shade. Or branch out a little more and tap into the fun pastel colors from a bag of candy hearts.

Or say you love Halloween but find black and orange to be too harsh for your home. Instead bring in different shades of orange like pastel coral and peach and switch the black to gray to make everything a bit softer. You can, of course, go classic with a carved jack-o-lantern, but use a different variety of pumpkin or even a faux one to avoid the standard orange. To create an arrangement of colors outside of the classic orange, try grouping pumpkin varieties like porcelain doll (peachy pink), jade knight

(jade green), and ghost pumpkins (white) along with a mixture of spotted gourds. This approach brings in natural autumn colors while also giving your décor a longer life before and after Halloween.

For the classic Christmas red and green, start with different shades of those colors. Mint green brings a lightness and playfulness, but still pairs well with evergreen.

And instead of, or in addition to, red, I love to bring in pink. Mint and pink are variations of the originals and not so far removed that you don't think Christmas, but also different enough to be your own. You could also lean into other elements of the holiday and season. Maybe you've always loved the crisp white snow, the softness of Christmas lights, or the color of the frosting on the cookies your mom bakes. Think about the details and what brings you joy about celebrating a holiday and the colors associated with it, then go from there.

Or if you have a favorite holiday movie, watch it and draw inspiration from that color scheme. My personal favorite is the original *How the Grinch Stole Christmas* cartoon from the 1960s, but that's because I love bold and bright colors for my Christmas décor. Your own palette might be influenced by a completely different memory. Not only will watching holiday movies help you find and explore more colors and decoration ideas, but it might also bring you joy and cement your own yearly tradition. Win-win.

Just because you want to create a new palette for your décor doesn't mean you have to buy all new pieces to make it work. Instead, go through what you already have and be selective about the colors you choose to bring out. It's okay to leave some pieces in storage one year.

Even if you don't usually decorate for holidays, you can still celebrate the different times of the year through seasonal décor. What colors do you associate with each season? Choose colors that have meaning for you, or turn to nature to see what colors are in bloom; for example, the yellow of blossoming daffodils or deep lilac for spring; the reds, purples, and oranges of fresh fruit for summer; the browns, yellows, and oranges of turning leaves for fall; and snowy whites and bluebird blues for winter. Bringing these natural elements inside can help your home feel more in tune with the seasons without having to commit to any celebrated holiday.

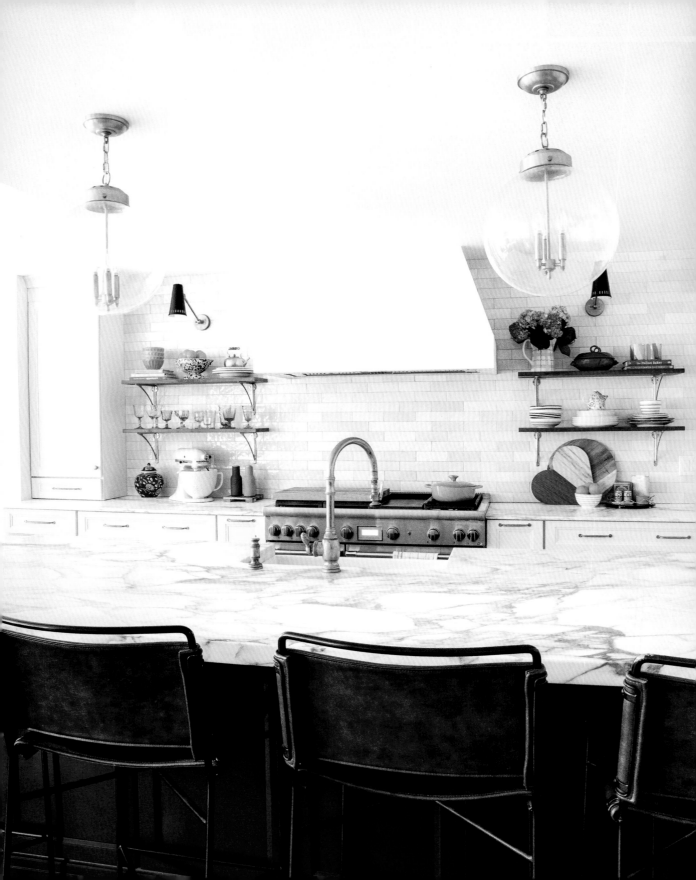

Chapter 8

THE RECIPE FOR A COLORFUL KITCHEN

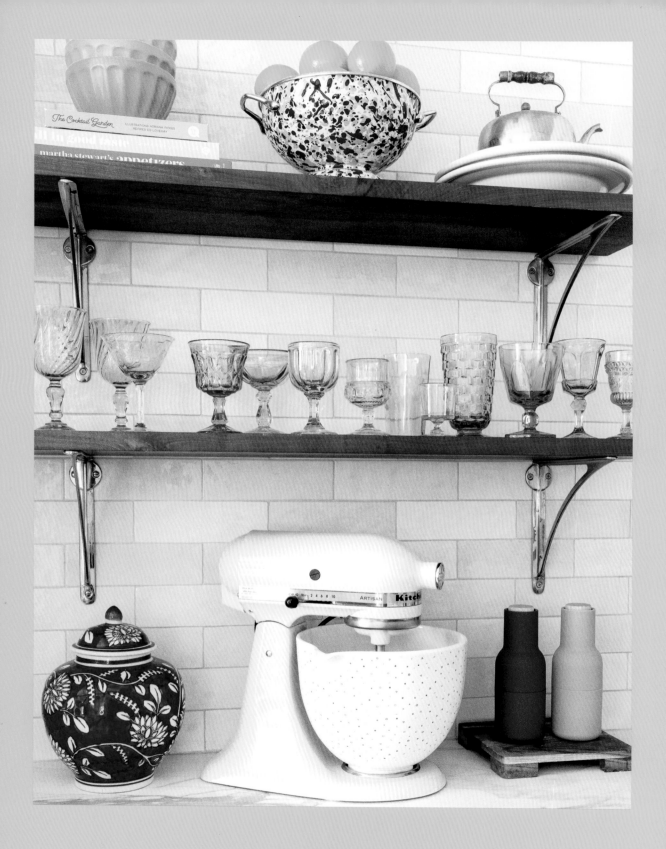

The kitchen is where you create, share, and enjoy meals multiple times a day, every day. It's where you nourish yourself and your loved ones. When you're not eating, it's a social hub. It's where you sit and chat over a cup of coffee or play your favorite board games. Even if you don't cook, the kitchen is undeniably the center of any home.

It's also a space where color can make all the difference. By nature, cooking is a creative act, so it's important to feed into that by giving yourself a space where you want to create. And what that means is completely a personal choice. Maybe you prefer to cook in a minimalistic room so the attention is on the ingredients. Maybe you like bright colors to make you feel energetic so you can cook your way through a four-course meal. Or maybe you prefer dark tones so you don't have to worry about staining. Whatever your preference, it's important to understand how your kitchen makes you feel and how décor changes the way you interact with this central spot in your home.

To help you understand the space you currently have, grab something to take notes with and sit in your kitchen. Meditate on how you feel in the space. Take notice of what comes to your mind first.

How do you feel at first glance?

What do you notice about the flow of your kitchen and how it's organized?

Focus on the individual objects—does anything catch your eye? Why do you think that is?

What do you like? What do you dislike?

How do the kitchen's colors make you feel? Do they feed your creativity?

Did you make a list of things you dislike immediately? Or was your first instinct to grab a pan and call your friends over for a dinner party? Did your eyes go to an unorganized area that bothers you every time you cook? Or did you admire one corner of the kitchen that's absolutely perfect? Maybe you were focused on figuring out what that food stain could be from?

Review your impressions and organize them into positives and negatives. Your likes are just as important as the things you don't like. They give you a foundation to grow from and point you in a possible new direction. Even if you don't want to tackle a full kitchen remodel, you can still replace items that don't bring you joy with those that do. Or maybe you enhance some areas with a renter-friendly DIY hack.

Elements of a Colorful Kitchen

Like with every room in your house, small changes revolving around color can make you feel like you have an entirely new kitchen. So review the negatives you wrote down (I like to think of them as "opportunities") and see if some of the kitchen color ideas that follow can help.

Appliances

Hate your appliances but can't upgrade? Try covering them with removable wallpaper instead. Wrap your fridge for an instant color and pattern boost. It won't damage the door when removed and is a renter-friendly way to make the space reflect your style.

To cover your stove or dishwasher, try heat wrap vinyl instead. This stands up to heat better than wallpaper and comes in a wide variety of colors. Check online or with a local auto body shop that wraps cars. They might even be able to match your exact Pantone shade if you're looking for something specific!

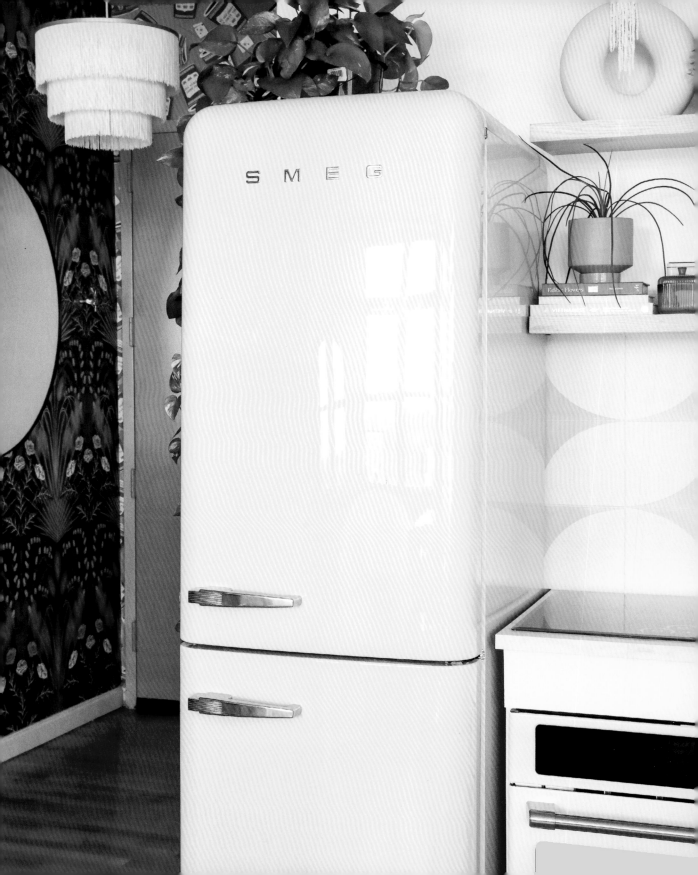

Add cabinetry panels to the front of your appliances so they blend seamlessly with the rest of your kitchen cabinets. The price tag for this can be high if you hire someone for custom work, but there are some affordable DIY options if you're feeling crafty. (Check out the *Merrythought* blog for one.)

And if you are able to upgrade your appliances, remember that stainless steel and white are not your only options. Smeg, Samsung, and Big Chill are modern brands that offer appliances in colorful finishes.

Cabinets and Shelves

Open shelving is the perfect opportunity to put a collection on display. If you don't have open shelving but have always loved the look, play around with removing your cabinet doors. This will give you a sense of openness without having to remove the cabinets altogether. Style the area so it feels intentional, or try your hand at displaying only monochromatic pieces.

If you like your cabinets but want to make a small update, swap out the hardware as discussed on page 130. You can really have fun here, so don't be afraid to add a bold color or unusual shape!

Go big and paint your cabinets. Maybe you just paint the outside of the doors, or keep the outsides as is and instead add a secret pop of color to the inside. Try mocking up your design in Photoshop or ProCreate before starting. SketchUp also has a free plan for personal use, or, if you want to get off the computer, use removable vinyl to get a feel for what it would look like with paint. I've also taken a photo of a space and played around in Instagram stories (without posting of course). It won't look realistic, but you can still get a sense of color play as a jumping-off point.

Display your favorite cookbooks by color. Or make your treasured pieces (your copper pans, homemade utensil crock, an impressive knife block) a focal point. Put these items out on display instead of hiding them away behind cabinet doors.

Floor Coverings

Add a machine-washable rug in front of the sink. Resist the temptation to splurge on a fancy or one-of-a-kind vintage piece only to spill pasta sauce on it.

Add peel-and-stick tile to the floor. There are many temporary options available (online, or try Lowe's, Home Depot, Etsy, Wayfair, or Amazon) that work well for renters or as a trial before fully investing in tile.

Paint your floors. Sherwin-Williams and Benjamin Moore make enamel paint that can be used on floors. Follow a step-by-step tutorial (home magazines like *Better Homes and Gardens* or even paint companies like Benjamin Moore have resources online) to ensure that you get the most life possible out of the paint. Try a single color or make a pattern (diagonal checkerboard, striped lines, or even a stencil if you're feeling ambitious).

Plates and Glassware

After the hard part of cooking a meal is over, or after you've opened the door to the delivery driver, it's time to enjoy your meal. Have you ever paid close attention to what you're eating on? This is one of those moments when you're subconsciously consuming color. It might seem silly to care about the color of your plates, but you use them daily, so why not be deliberate?

As a self-proclaimed dish enthusiast, one of my favorite things to do for my home has been to build a colorful collection of plates, bowls, and glasses. I started mine a few years ago and still don't consider it finished. There's something so lovely about taking the time to collect pieces that make me happy. Not just happy at the time of purchase, but every time I use them. I know that's a lot to ask from a dish, but when you build with intention versus convenience for your home, you tend to buy pieces that you'll have for a while.

What helped me to build a cohesive dish collection was to go into it knowing what colors I wanted to stick with. I love blue, so I used that as one of my base colors and focused on different shades within that color. I have light blue bowls, deep denim plates, and a range of blues in between. Even though everything is not the exact same shade, they all match in a monochromatic way. It's matching without limiting myself to one brand or one exact color. This choice makes it easier to add to my collection as the years go on.

Some tips on building your own collection:

- If you are *just* starting, please, go to Ikea or a thrift store and buy some dishes to use while you build. Invest in your lifetime collection, but don't deprive yourself because a dish isn't colorful or perfect. The idea is to grow your collection over time, not pull an HGTV makeover episode in a few short days.

- Pick pieces that make you feel special, because every time you eat on them, they'll make you feel that way. Build with intention and a color palette. Quality over quantity always!

- Look for dishes at antique malls, local businesses, and craft fairs, and when you travel. If you find vintage glassware, test them for lead before using daily (buy a lead testing kit at stores such as Home Depot or online).

- If you're sticking with white or neutral colors, consider researching ceramic artists. You might be able to build your collection with unique and organic shapes. White comes in *so* many shades, so you're bound to find something as unique as your collection will be.

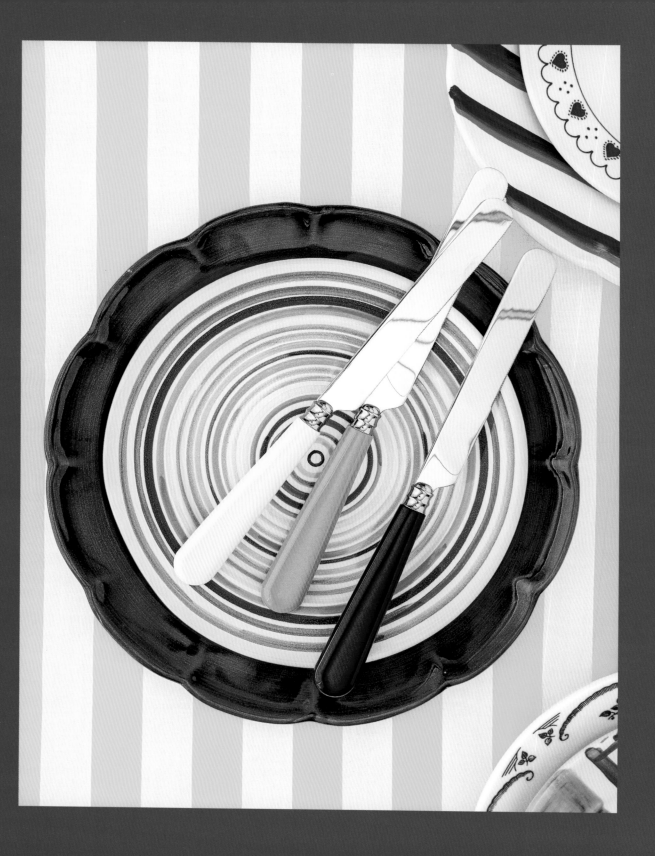

- Feel overwhelmed by choices? Can't decide what to buy because you love everything? Create a mismatched collection! Nobody said your dishes must match. In fact, having different tableware can be a conversation starter, especially if you display your glasses on open shelving in rainbow order. To add some cohesiveness, stick to similar sizes so everything stacks well.

- If you love the dishes you already have, consider building a small collection that you use only for special occasions. Maybe you invest in a specific brand or the work of an artist you love. In the past, couples often registered for fine china before marrying, but you don't have to be part of a couple or married to have a reason to celebrate with something nice.

Silverware and Serving Utensils

If you can believe it, silverware now comes in more than just silver. Let's call it flatware. In fact, you can find gold flatware, patterned handles, even rainbow titanium plating. Really the possibilities are endless; you should be able to find a set of flatware that matches your kitchen color palette with ease. Try sourcing options at art museum stores like the MoMA Design Store, specialty cookware sites like Food52, or small online boutiques like Matilda Goad and Co. There are endless resources beyond Amazon if you don't mind spending time on Google and Pinterest searching for them. Some of these specialty items can be hand-wash only, so keep that in mind when looking for your new favorite set if you hate washing dishes by hand.

If you like the classics and want to stick with silverware, by all means do! You can still bring in your color palette with serving utensils. Spring for the leopard-print salad tongs, because why not?!

Color Exercise:
A Colorful Dinner Party

Looking to really explore color in the kitchen? Host a color-themed dinner party. Choose one (or more) colors and organize the menu, décor, and dress code around it. Following are a couple of examples, but you can go as wild as you want.

RED: Cook spaghetti, drink red wine, and serve a tomato salad, roasted red bell peppers, and strawberry cheesecake or red velvet cake for dessert. Ask everyone to wear something red and set a vase of red dahlias on the table atop a checkered red-and-white tablecloth. Can you think of any red-themed music to play?

GREEN: Grill steaks with chimichurri sauce, drink mojitos or mint juleps, and serve a green salad, sauteed zucchini, and matcha pound cake for dessert. Make this an outdoor dinner party or a picnic at the park surrounded by nature. Assign a type of tree to each guest and make themed place cards. The possibilities are endless.

To host a weeknight version of this idea, invite friends over for snack night and ask each guest to bring a snack in a set color scheme. It can be the color of the snack itself or even the packaging it comes in. It'll be fun to see what everyone thinks of when given a color prompt, and you'll have snacks for your night without much prep work.

Napkins

Cloth napkins are a dining must! Not only do they bring color and pattern to your table, but also they are what I consider to be an everyday luxury item. Using a cloth napkin can make a meal feel special, even if you're just grabbing takeout.

Cloth napkins are machine washable and last for meal after meal, making them an environmentally friendly choice. If your napkins ever start to fade or get stained, dye them a new color. And if you're feeling crafty, try sewing your own set in your favorite colors. Linen or cotton works best for durability, and don't forget to add a unique detail like trim or contrasting thread.

Choose napkins that match or complement your tableware and flatware, or change them out according to your mood, your menu, or the seasons. Paper napkins are great for bringing in festive and holiday patterns. Or make them mismatched—maybe to go with different chairs around your table. You can have more than one set of napkins, so really explore color here to mix up your tablescape.

Placemats and Table Runners

If you're keeping your dish collection neutral or you love maximum color, placemats and table runners are another way to add color to your table without fully committing to a single palette. When they're not in use, store them in a cabinet or go all in and display them on your table as a kitchen accent.

You can also use placemats and table runners as an opportunity to create a theme. For example, if your dishes are green, bring in a floral-print runner to create a garden party atmosphere. Or choose a runner with stripes and placemats made of natural fibers and it's like you're dining outdoors in Nantucket (even if it's mid-January). Another idea is to use different colors for specific times of the year (think: warm shade for summer, cool tones for winter) to further immerse you in the season.

Serveware

A pitcher is an excellent double-use product, because when it's not in use, you can display flowers in it. I have one made from colored glass instead of clear so you can still see the drink inside (perfect if you've added lemon peels or another pretty garnish) and it adds an interesting color to the room when it's part of a display.

It's never a bad idea to have a bold and brightly patterned option. These types of pitchers are often made of glazed ceramic. If you can't find a version you like, buy a plain ceramic pitcher and paint your own design on it. Pebeo Porcelaine paint is my go-to (just be sure to hand-wash it so your design lasts).

If you're sticking with neutral colors, look for a container with an interesting shape or texture or a funky handle to give it a unique feel.

When it comes to other serveware like platters and trays, consider how and when you'll be using each piece before you invest. Is it for a specific event like a holiday, for occasional entertaining, or for regular mealtime? Your serveware's likely function will help you determine what colors and patterns to look for, especially if it is going to be used often. You don't want it to clash with your everyday dining décor like your table runners and serving utensils, but you also might want a few special pieces for big or recurring events.

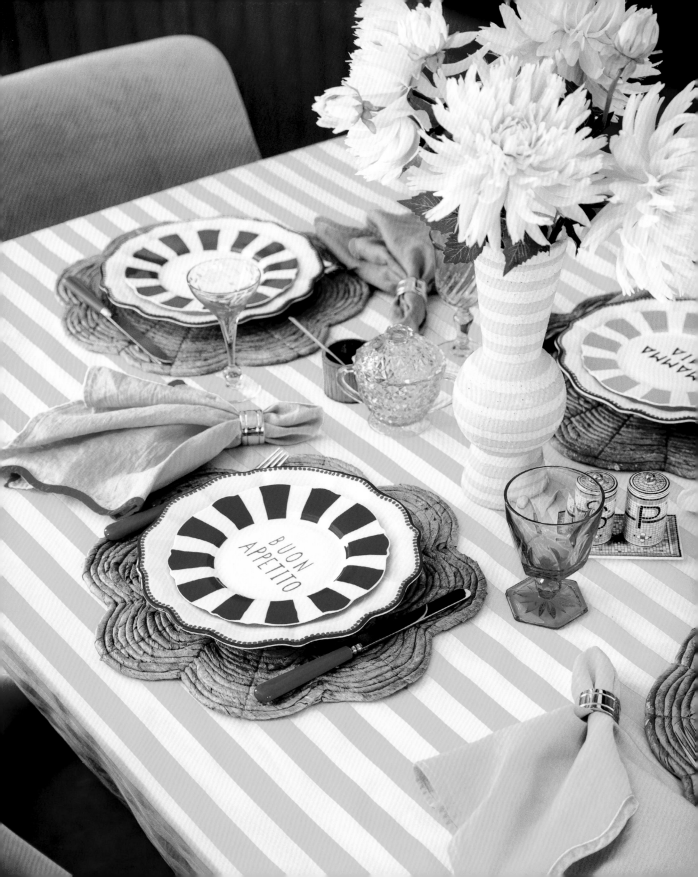

Organizing Your Kitchen by Color

Remember back in elementary school when we had colored folders assigned to different subjects? How many of you used green for science and blue for math like me? If you used other colors, I bet you can recall them now, despite the years or even decades that have passed. It turns out that we've been organizing by color for our entire lives maybe without realizing it. I say, let's tap back into colorful organization!

By now we've all seen photos of those perfectly organized kitchens floating around on the internet. And while they are visually pleasing, there are beneficial reasons for organizing your kitchen by color beyond aesthetics.

Knowing what food you have and where it is will reduce your food waste and save you money in the long run. It might also inspire you to cook more, because you remove the hunt for ingredients from your experience. Your focus can turn to the food instead of the search. Have you ever been in the middle of cooking and realized that you have run out of an ingredient (or couldn't find it at all)? Do you ever open your fridge and discover that half of what's inside has expired? Setting up a system can change those experiences for you.

Foods naturally come in a rainbow of colors; no paint or crafting is needed to see their beauty. Simply by storing your food in an organized way you can make your home a more colorful space. You can, of course, add even more color to your organization systems, and I'll show you how, but using what you have is always the best starting point. The way you store and organize your food and spices might even help you see and consume them in a new and more colorful light.

Clean Up That Fridge

As someone who has used many a tiny fridge, I can firmly say that having an organization system in place is a game changer when it comes to making the most of what you have and reducing food waste. (I can't tell you how many moldy lemons I have found in the back of the fridge.)

You don't have to stock your fridge to capacity for it to look like a magazine spread. You can even make a small renter fridge work for you. The main goal is to first be able to see everything you have. This creates visual interest while cutting down on waste. From there, we can make storage more functional and colorful. As silly as it sounds, you can even use the food as colorful décor. Fruits, vegetables, and product packaging are already colorful; arranging them in a thoughtful way creates a fun color story.

Start by pulling everything out of your fridge and cleaning the inside doors, shelves, and drawers. Beginning with a fresh, clean base is always the best way to begin any organization project. It helps to start this process once you've gone to the grocery store for the week so you know how much food you need to accommodate for. From there you can see what you have, what's expired, what's missing, and what you might need to replace in a second trip to the store. Make a grocery list and then group your items into piles by category: for example, all the meat, all the fruit, all the cheese, and so on. Having your items in groups will give you a sense of what foods you eat the most and which might need extra organization.

Before you place everything back inside, set up a system of organization so you don't have to repeat the remove-and-clean process in another week or two. Containers can help you wrangle items that get loose in the fridge (remember my lemons, won't you?). If you don't have built-in drawers for things like meat and

produce or shelves in the door for jarred items like pickles and sauces, containers work well for these items too. Measure the length and depth of your main shelves so you get containers that fit. You want them to fit together all the way across the shelf so you don't waste any space.

If you're not interested in containers, consider adding a spinning shelf for jars and other odds and ends that might get lost in the back of the fridge. Or simply add labels to the shelves so you know where certain items are stored. You can institute a color-based label system (brown for breads, red for sauces, green for herbs) if that helps. The goal of the system is to have a place for everything instead of just placing food haphazardly inside.

Refrigerator containers or bins are usually made from clear plastic so you can see what's inside each one. Put your colorful labels on the outside or use a bright-colored paint pen to mark what's inside. You can also let the color of the food speak for itself. You'll start to see a color story develop once you organize your items into the containers (green veggies next to orange and white cheeses next to a rainbow of fruits).

Instead of storing your condiments on a shelf or in the door, move them to a crisper drawer at the bottom of your fridge. If you're like me and hate to bend down to the bottom of the fridge to look for fresh food, this is the perfect swap. Moving your condiments to a drawer clears up prime eye-level real estate in your fridge for perishables. Meanwhile, you know exactly where your favorite sauces are.

Shelf liners can be another colorful addition to your fridge. They can help you color-coordinate (maybe produce goes on the shelf with a blue liner), or you can use them just for fun. Stick a different color on each shelf, the same color throughout, or go for a more monochromatic look and use different shades of the same color, placing them darkest to lightest from the bottom shelf up.

The best part about shelf liners (aside from the added color) is that they help keep your fridge clean. More often than not, they are made of silicone and can be easily removed or wiped down. Check out Amazon or your local home décor store for options.

Next Up, the Pantry

Your pantry space can create a color story in three ways: through the products themselves, the containers you place them in, or the pantry space itself. And if you really want your pantry to be a colorful place, then make use of all three ways at once.

When it comes to organizing packages of food, it's smarter to organize by ingredient than by color; just because an item comes in a blue box doesn't mean it goes with the rest of the blue boxes (one could be pasta, the other cookies). You want your system to make your day-to-day easy instead of making simple tasks harder. When organizing your pantry, consider the item's use and establish a flow.

Group packages into categories (sweets, savory snacks, grains, canned goods, and so on) and go from there. Create a mini-rainbow or use a different color order per section. Having multiple sections in color order tells you when one section ends and another one begins so you can find items faster.

If you don't want to store food in the packaging it came in, change the color story with containers. If you like the color of the item itself, use a clear container and let the product shine. This does require the effort of transferring ingredients to containers, but it can bring a sense of order to your pantry. Just don't forget to write down the product expiration dates when removing them from their original packaging.

An easier approach than swapping one container for another is to wrangle your items in baskets or bins. These come in many sizes, shapes, colors, and materials. Maybe you go for a gold wire basket for a glam look or choose a woven basket like you'd see at a farm stand. If you don't find what you like, you can always dye or paint them. Discount home stores like HomeGoods offer inexpensive options if that's a route you want to take. Neutral-colored baskets are most common, but you can always dress up the outside with colorful labels. If the basket surface is textured, use a basket tag or a label that can clip on the front.

The pantry space itself can be a fun place to play with color because more often than not it's behind doors, whether you have a few cabinets in your kitchen or a dedicated room. This means you can experiment with colors that you might not otherwise use.

Wallpaper the shelves, paint the walls or inside door, or lay down shelf liners. For a more subtle color pop, wallpaper just the back wall of the pantry and keep the shelf area unadorned. Choose a color palette that goes with your bins and food organization system so you don't overstimulate yourself when looking for something to eat. Combine fun and function so you can find the things you need in a space that you love.

And Finally, Your Spices

This is an area where organizing by color really helps you find things faster. When you organize spices by color (separate cayenne, chili flakes, and paprika from dried rosemary, oregano, and sage), you can easily narrow down your hunt to a specific spot in the drawer or on the shelf. Place the green spices with other green ones, white spices with other white ones, and so on. This creates a natural rainbow and speeds up your search time.

If you want a uniform shelf, swap out the original spice jars for a set of glass ones. Add your own labels with stickers, vinyl cut with a Cricut machine, or a label maker. Apply your printed stickers on the lids if your spices live in a drawer, or at the top or bottom of the jar depending on your shelf. Or head over to Etsy and have a maker create something entirely custom for you. Maybe you buy colored lids that will help you stay organized. Think of what methods will help you locate things quickly, as well as what fonts and colors you like.

Consider the area where you store your spices. Is there a way to bring color to the rack you display them on? If they're in a drawer, can you paint the inside of the drawer or line the bottom with colorful paper? Maybe go out and buy some new spices you've never tried before. Did you know that peppercorns also come in white and pink? Head to your local bulk bins or spice store and have fun exploring new colors and flavors. And however you decide to customize your spices, mark the expiration date on the bottom.

However you start adding color to your kitchen, be sure to follow your heart to make the center of your home a joyful space. And as always, let color be your guide.

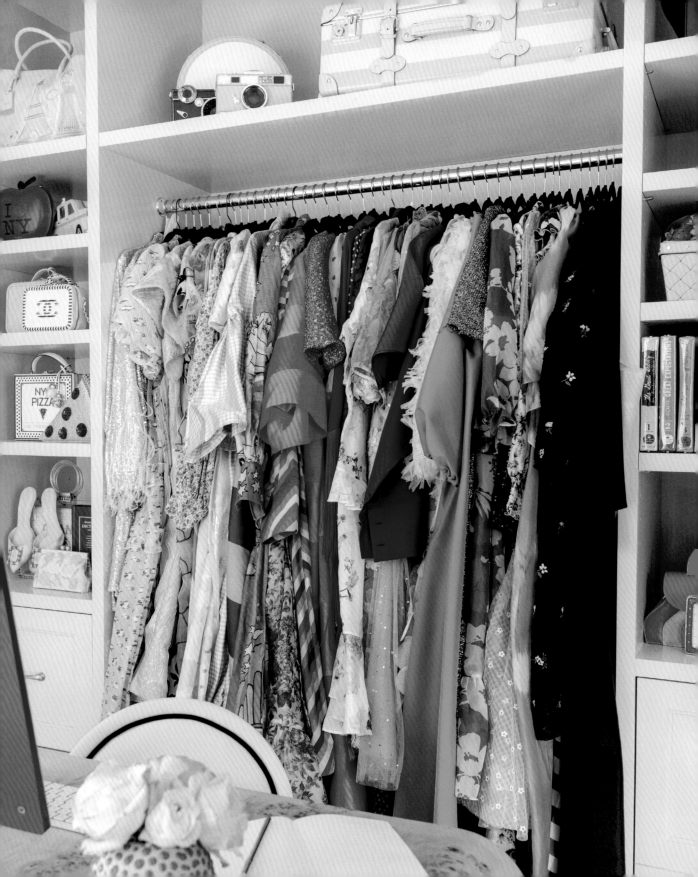

Chapter 9

BE BOLD
(OR KEEP IT SUBTLE)
WITH YOUR FASHION

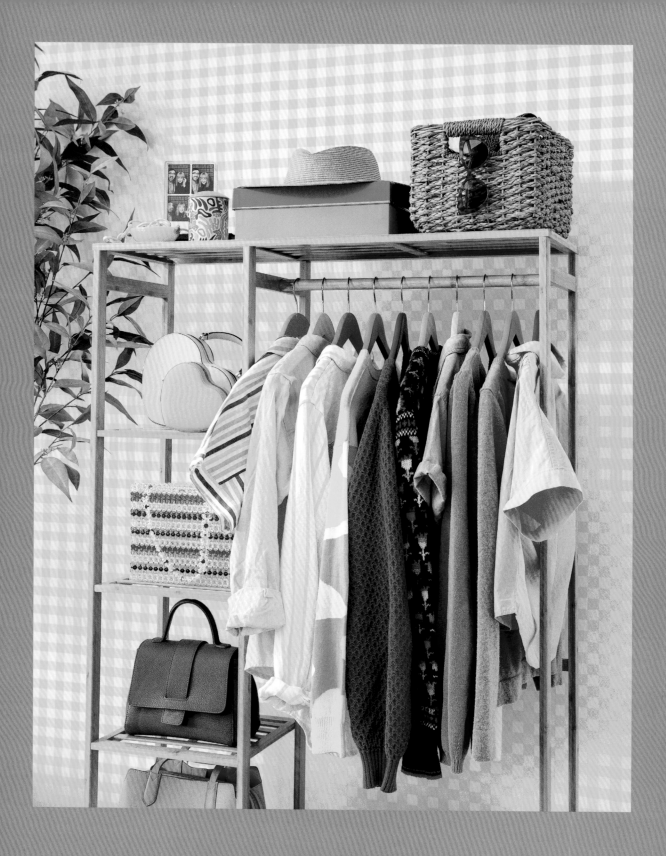

"You only fail if you do not try. . . . Sometimes you have to take action, even if it's a small step. In my ninety-some years of walking planet Earth, I have applied this philosophy to living—and dressing—and it has never steered me wrong."

———

IRIS APFEL

Fashion is a form of self-expression and an opportunity to tell the world who we are. Getting dressed in a thoughtful and intentional way can help you tap into happiness, give you a way to reconnect with your younger self, and boost your self-confidence.

Experimenting in your wardrobe is another way to add color to your daily life, because as long as you're not a nudist, you take your clothing with you everywhere you go. Before style and fit, color is often the first thing people notice about an outfit. Even if you live in a not-so-colorful place, you can be the one who brings the vibrancy. Clothing, makeup, and accessories can all be used as tools to ensure you see the color you want to see in the world. It might be rainy and gray outside, but the moment you step out your front door, you can bring the sunshine with your outfit.

Whether you dress for comfort, style, or function and regardless of your size or the labels on your clothing, I want to help you dress for you. If you don't have the confidence to wear the colors you love, I hope the following pages get you there. I'm also going to talk about how to choose the colors you look best in. We did not survive a global pandemic to be intimidated by a pair of lime green earrings or a bright yellow blouse. We all have it within us to dress the way we want right now at this very moment. Let's embrace it.

How to Choose Your Best Colors

Have you ever gone into a job interview or big life event wearing your lucky color? Do you have a power color that makes you feel amazing every time you wear it? Or a go-to color you wear anytime you go shopping? Color has the ability to change how we feel in an outfit, and it has nothing to do with size or expense.

Let me start by saying that of course you can and should wear any color that makes you feel good. That's the point of fashion, isn't it: to make ourselves look and feel great through our clothing? But there are also certain shades of color that can enhance our features based on our natural undertones, whether they're cool, warm, or somewhere in between. Because of the concept of color relativity, humans may read colors differently when they are next to each other. Sometimes the colors enhance each other, making both shine a bit brighter. But they also have the power to wash each other out. This is true in color theory as it relates to art, and it's true for fashion, too.

Knowing which colors complement your undertones can be the difference between feeling okay and feeling amazing when getting dressed. After discovering the colors you look best in, you'll be able to shop with the peace of mind of knowing that the colors you chose will ultimately help you shine. You might even get a little confidence boost because *your* colors will naturally pull out your beautiful features.

Did you know that there's a whole profession dedicated to helping people discover their best colors? It's called color analysis, and practitioners help you find out exactly which shades enhance your appearance, either by reading your colors in person or through an online session. (Anuschka Reese offers online sessions if you're looking to get started right now at home.)

While this idea certainly isn't new—the book *Color Me Beautiful* has been around for decades, after all—it's one that has lasted, because it's rooted in color theory.

If you don't want to have your colors professionally analyzed, there are ways to figure it out yourself. The process consists of holding different shades of color up to your skin and seeing how they make you look. Most color analysis organizes categories of color by the seasons—winter, spring, summer, and fall—and get even more detailed from there; for example, winter can be further divided into true winter, bright winter, cool winter, and dark winter.

Here are the main categories:

WINTER: jewel tones like emerald green and sapphire blue, and stark neutrals like black and white. Bold and contrasting colors work well.

SPRING: warm and vibrant colors like yellow, orange, peach, and those with warm undertones like brown. Steer clear of cools or pastels.

SUMMER: softer, muted colors like taupe, blue-gray, soft white, and cool-toned pastels.

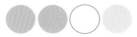

FALL: rich, dense, and warm colors. Gold and golden browns, leaf green, teal, and pumpkin orange.

To determine which category you fall under, you want to see the various colors against your bare skin so you can objectively compare and contrast them. Wear all white so that no other colors interfere with the ones you're testing. The goal is to see if they wash you out or enhance your natural coloring, so removing all other colors is key.

There are a few ways to do this exercise on your own. You can order a swatch kit online or use the clothing you already have at home (provided you have a wide selection of colors). Or head to a store and try on a variety of different colors in the dressing room. Instead of trying on clothes for fit and style, just pick them based on color. You could even hold fabric up to your face at the fabric store—as long as there's a mirror to look in. It's best to test your colors in bright, natural light. The fluorescent lighting in stores might not give you the most accurate results, but it should still point you in the right direction for exploring more.

If going somewhere in person isn't your thing, try an app filter (TikTok has one that was recently popular) or take an online quiz to help you get started. Fashion magazines (try *InStyle*) are a wonderful place to begin. If you know how to work in Photoshop, you could use an unedited photo of yourself and create a color palette from that. Just use the color dropper tool to isolate the different tones in your skin, hair, and eyes. Regardless of your approach, don't wear any makeup, and pull your hair out of your face so you can see how the colors look against your skin and how they enhance (or don't) your eye color.

Once you've determined your main seasonal category, it's time to dive into your closet to see if you've been wearing your colors or not. If you love some items of clothing that turn out not to be one of your best colors, don't toss them! This doesn't have to be a strict guideline. Have fun getting to know your colors and learning more about yourself, while adding to your wardrobe over time. The goal is not only to help you find colors that you enjoy, but also to identify the ones you instantly feel better in because they complement your natural beauty. And who doesn't love an excuse to get a new outfit?

Brighten Up Your Accessories

Remember when I said that decorating your home with accent pieces is like adding a statement necklace to cap off an outfit?

Accessories are your chance to add fun pops of color, funky patterns, and even mismatched prints to your look. Bright colors and patterns bring interest to a neutral look and can make your brights even brighter. In the simplest terms, accessories accent

and highlight your clothes while adding oomph and polish. And because these finishing touches are generally small (as compared to a dress or a sweater), adding them to your outfit won't overwhelm a look, regardless of how bold you go with your color choices. You can change them up with every outfit, so experiment!

Regardless of how your body changes with time, your accessories will almost always fit. You don't have to worry about outgrowing earrings, and rings can always be resized. You might have to pull your belt tighter or loosen it up, but that's okay. It's also okay to invest in your dream purse, because you could possibly have it for a lifetime. In fact, accessories may help you get more life out of your clothes and save some money in the process, because with a few quick accessory changes, you can have a different look altogether. So, play around, have fun, and don't be afraid to bring in the color!

Glasses

Go bold: Try brightly colored lenses in your sunglasses. Even if you wear prescription lenses, you can get mirrored lenses in a variety of colors. Pair them with an eyeglass chain so you can wear the glasses around your neck when they aren't on your face. This additional accessory brings in more color and helps you to not lose your glasses. In addition to your day-to-day pair, have a bold pair of glasses that pushes you a little out of your comfort zone. Wear these on days when you need a little boost, because there's no way you won't get compliments on how good you look.

Keep it subtle: Ditch bright and bold for a completely unique pair! I love shopping at flea markets and on Etsy for vintage glasses. Most opticians will change out the lenses for you (though it's best to call and confirm that before you splurge on a brand-new-to-you pair).

Earrings

GO BOLD: To really show off your earrings, pin your hair back on one side or pull it up altogether. The more visible your ears are, the more likely your earrings will be the first thing people see. Go big with a statement earring in a bright color. Bring out the rhinestones. Pick your loudest pair and let them be your outfit conversation starter.

KEEP IT SUBTLE: If you have more than one piercing in your ear, create your own color palette for your ears, using studs that are all different shades of your favorite colors. If you only have one piercing, try wearing mismatched studs (a different color in each ear).

Rings

GO BOLD: Cocktail rings are the perfect go-to for a statement ring. They're large, chunky, and often come in a variety of different-colored stones. And costume jewelry is much more affordable because you aren't wearing real stones. The lower price point gives you plenty of room to build your own collection.

KEEP IT SUBTLE: Thin colorful bands can have an impact when you stack them together. Wear three or more on the same finger for a fun palette. Or add a colorful band to your other metal jewelry, even your wedding ring. A touch of classic meets that pop of color!

Bracelets

GO BOLD: Layer several bangles or beaded bracelets together to create your own color story. Pick a variety of materials and bracelet widths to create interest. Layer in a watch for a bit of functionality.

Keep it subtle: A metal charm bracelet in classic silver, gold, or rose gold is a traditional option that you can freshen up with a charm or two in your favorite colors.

Brooches

Go bold: Big vintage stone or flower pins can make a statement, especially when you pair two to four of them side by side. Pin them to a jacket, blazer, or even a dress. Or add them at the top of a collared shirt, where you'd wear a tie. If you have a coat that you wear open, you can even swap out the buttons with some brooches. Antique malls have a variety of these pins and they often come in wild colors and designs.

Keep it subtle: Enamel pins do the brooch trend in a subtle and sweet way. They're smaller than typical brooches, so they add a touch of whimsy without being the focal point of a look. Wear them on a jacket or pin them on a purse or backpack.

Scarves

Go bold: In addition to the usual accent scarf worn around your neck, make a colorful statement by wearing one in your hair. Use smaller scarves in silk or stretchy cotton and tie one around a ponytail, twist one and wear it as a headband, or fold it like a bandanna and cover your hair.

Keep it subtle: Add a scarf to any bag's strap to bring subtle color and pattern to a neutral purse. Or match your bag to your scarf for a monochromatic moment. Play around with options and swap scarves in and out with your outfits.

Belts

Go bold: Wear your belt over your outfit to create a waist on an oversized look: Belt a blazer, a dress, or a sweater. Make it pop by using a bright contrasting color. If you have multiple skinny belts, layer two colors.

Keep it subtle: Tuck in your shirt to show off your belt (or do a French tuck and only tuck in the front) to bring attention to the belt. Contrasting the color of your belt with the color of your shirt (especially if your pants are simple, like jeans) can make for a dynamic color combo.

Purses

Go bold: There is no shortage of bold purses in the world! Choose a brightly colored or patterned bag to accentuate an outfit. Look for bags made with unusual textures and materials, or sparkly accents like beads and sequins.

Keep it subtle: Swap out the strap of your purse for one in your favorite color. You can invest in straps rather than new purses for a great way to save money but still change up your wardrobe (or borrow a strap from another purse you already have).

Headbands and Hair Accessories

GO BOLD: Headbands, claw clips, and barrettes come in so many shapes, sizes, and colors. Wear two or three barrettes in different colors side by side, or stack your headbands. Think of hair accessories like jewelry.

KEEP IT SUBTLE: Use brightly colored bobby pins to pull back some of your hair or just to add some color and make a statement. If you can't find bobby pins in the colors of your choice, paint them with nail polish.

Hats

GO BOLD: When it comes to making a statement with a hat, color and size are your friends. Maybe you lean into an oversized style (think: big, floppy beach hat) that speaks for your whole outfit. Or try bringing out a color in your outfit with a bright, coordinating hat. Match your hat to your shoes or your jewelry or your glasses or your hair color!

KEEP IT SUBTLE: Choose a neutral-colored hat and add colorful embellishments like a ribbon or a feather for a slight pop of brightness. With removable pieces like these you can change your look with each outfit.

Shoes

Go bold: Shoes can easily be the most iconic part of an outfit (think of the ruby-red slippers from *The Wizard of Oz*). When you go bold with your shoes, regardless of what else you're wearing that day, you can look down at your feet and see color wherever you go. So invest in shoes that bring you joy: a glitter boot, a neon pink velvet flat, or heels with a rainbow pattern. Don't limit yourself when it comes to color or pattern. A statement shoe stands out according to what you pair them with. Topping off a black or otherwise neutral outfit, the shoes will make a strong statement without overwhelming the look. When paired with more color, you take your outfit to the next color level. And for that extra pop, add a brightly colored pair of socks to peek out above your shoe.

Keep it subtle: If you have a good neutral shoe, let's say a classic white sneaker, try swapping out the laces for something more whimsical! Shoelaces come in a variety of colors (and not just white, cream, brown, and black), so mix things up depending on your outfit. Ribbon also makes for a good lace, especially for a boot, when you want a fancier look. Measure the size of the original laces to ensure the new ones fit just as well.

Personal Beauty

You might think that certain beauty practices are modern trends, but humans have been altering our bodies and experimenting with color for thousands of years. In fact, nail polish is said to have originated in China as early as 3000 BC. Tattooing has been around since neolithic times. Even makeup was used by Egyptians as early as 4000 BC. And that's just what we have uncovered so far about ancient life.

While practices and applications have certainly evolved since their inception, the idea remains the same. Humans are naturally drawn to the idea of changing our appearance through color and beauty practices. Today, not only do we have significantly more color options, but we also have endless resources to help us learn creative application techniques. You can go to school to learn about hair and makeup or just pick it up as a hobby by watching videos or reading blogs online.

Beauty practices are an art form, a way to explore your creative side, and the perfect place to experiment with color. At the end of the day, if you don't like your look, just wipe it off and try again the next day.

Here are some ideas for bringing color to your beauty routine.

Nail Polish

If your job involves making with your hands or typing all day, why not make it fun?! Choose a color you love instead of a practical one. If you tend to use the same color every time or play it safe with a color you know won't bring attention to your hands, try a color you wouldn't typically choose. What color does your eye immediately go to at the salon? Try that one. Have a design or pattern applied or experiment with different acrylic shapes.

And who says you must stick to one color? Play around with painting each nail a different color. Use the color palette you created for your home as inspiration for your nails. Mix up different shades of the same color or move from darkest to lightest. Paint your nails the color of the rainbow if you like!

Once the polish is on, check in with yourself each day. How does the color make you feel? How different is it than what you typically pick? Did the color only bring you joy in the jar, or do you still love it on your nails? You may not always get colors you enjoy wearing every time, but the experiments will help you understand more about why you like what you like.

If nail polish irritates your nails, look for vegan or toxin-free formulas; they are often gentler.

Makeup

While some brands charge a premium for their products, there are ways to experiment with color in your beauty routine on any budget. When trying a new color in a product you already use regularly, test it first before splurging on a designer brand. Head to a pharmacy or a big box retailer (Elf and NYX are quality affordable brands). Or stop by a beauty store like Sephora or Ulta, where free samples abound, and play around!

Try to find products that work on multiple areas of your face (for example, a blush that doubles as a lip or eye color) so you can experiment with different shades. If you always go for black eyeliner, try navy or even pink. Or rock a monochromatic look with the same color for cheeks, lips, and eyes. You can always wipe it off if you don't love it, and there's no harm in having fun.

The makeup itself is a colorful product. If your brands come in pretty packaging, display your favorite pieces instead of tossing the boxes into a bag or drawer! Line up your nail polishes or

lipsticks in rainbow order. Use clear containers to display what you have in a functional way. Not only do you get the color benefits as part of your beauty routine, but this is also an easy way to add color to your bathroom or vanity with what you already own.

Hair

I've been dyeing my hair since middle school and have been pink for the past eight years. It took me a long time—and a lot of failed dye jobs—to find the hair color that I think complements my skin tone the best. Since I've had pink hair, countless people have told me that they wish they could pull off something similar. And I'm always left wondering how much more colorful the world would be if people were allowed to or let themselves dye their hair whatever color they want.

If your job won't allow you to have colorful hair, or if you're just not ready to commit, the good news is that there are temporary solutions for those who still want to experiment! Look for shampoos and conditioners that deposit temporary color. The color won't be as rich as it would have had you bleached your hair first, but you'll still see a tint. Hair chalk and colorful hair sprays can also give you a change that washes out with your next shower.

Have a wig party with your friends to see how you look with different styles and colors (ask each person to bring a wig so you have a variety of colors and cuts). This is a fun theme night without a big investment.

And if you do want to experiment with hair dye, try dyeing just the ends of your hair a bright color. This is a go-to technique that's easily removed if you are planning on a major haircut later on.

Organize Your Closet with Color

Is it just me, or does your closet need to be routinely organized too? Because we use our closets daily, and sometimes even more than once a day, they tend to get a bit messy and chaotic over time. That's where an organization system can come in handy to keep your closet mess at bay and bring in color to create joy.

Organization gives us a sense of control. When life feels overwhelming, having systems in place for our day-to-day actions can help us feel more on top of things. And an organized home is believed to lower stress—something I think we all could benefit from. When you're scrambling to find something right before you have to leave (or are already running late), it's never a positive experience. If you know exactly where everything is, you'll be less stressed about getting to where you need to be on time. Basically, having a system can help you avoid a whole stressful chain reaction.

Another benefit to organizing is that you save time overall and increase your productivity. That's win-win for any situation! You have more time for the things that matter. Finally, you can use color to help you remember where things live and make the color part of your décor. It's one more way to build a color story by using what you already have and use every day.

Remember, you don't have to organize everything all at once. In fact, it's almost always better to break up tasks by area so you can enjoy the process. I can't tell you the number of times I have pulled everything out of a cabinet to reorganize, only to lose steam halfway through the project and create an even bigger mess than I started with.

Getting dressed can be stressful enough, so let's eliminate the clutter and have some fun.

Here are a few of my tips to organize your closet and use color to help it stay that way.

Before you start organizing, pull out everything you own so you can see it in a different light. It's easy for pieces to get hidden behind others, especially if your closet is at capacity. Find space on your bed or floor to work. This creates a bit of a mess to start with, so if you don't have time to go through everything at once, work on one section at a time. For example, shirts one day, pants the next.

As you're looking over your clothes, make three piles. One for items you want to keep, one for items that need mending, and one for items to be donated. Donate the clothes you no longer want to wear (the ones that don't make you feel like your best self). A good rule of thumb is to get rid of clothes that you haven't worn in the past year (and that don't have sentimental value) or that just don't fit anymore. Yes, I know what it's like to keep a certain pair of jeans in case I might fit back into them one day, but now I have a new philosophy: You don't have to change your body to fit the clothes. Let the clothes change for you! Donate anything that isn't meaningful or that you haven't worn, so the items that remain are the ones you'll wear and enjoy.

As you're going through your wardrobe, ask yourself if the item is something that makes you feel good. Does it bring out the color of your eyes or your hair? What colors do you own the most and least of? What color is your favorite piece of clothing, and are you actively buying similar items? Use organizing to learn more about yourself and your style.

Color Exercise:
Store Your Clothes by the Seasons

One way to save space in your closet, get more wear out of your wardrobe, and change up your closet's color story is to store your clothes by the season.

You probably already dress seasonally (shorts in summer, sweaters in winter). Storing your clothes seasonally just means that instead of having your entire wardrobe available in your closet all year round, you rotate pieces in and out. You really won't need that cable-knit sweater when it's 105 degrees out; nor will you wear that sundress in a blizzard. So instead of keeping items that you won't wear in your closet, store them elsewhere until they're appropriate.

Think about what you'll need for the current season. If you won't wear it during the next three to four months, go ahead and store it.

Use vacuum-seal bags to suck out the air and reduce bulk if you have limited space, otherwise clothing bins work well. Store bulky items under the bed or make the containers part of your décor. Maybe you dedicate a certain color to a specific season (like fall clothes in a mustard-colored basket), or if your storage will be visible in your room all year, buy containers in the colors of your home palette.

As the weather changes, repeat the process. This way, you get a look at your wardrobe to see what you wore and what you ignored and can donate as the year goes on rather than trying to remember what you didn't wear at the end of the year.

What colors do you notice in your seasonal clothes? Do you lean toward bright colors in the summer months and neutrals in the winter? Are there any opportunities to bring in your favorite colors all year round? Hopefully this method gets you more acquainted with the pieces you have and helps you connect with how your wardrobe color preferences might change throughout the year.

There are two ways to use color as a tool for organization. The first is to hang your clothes in ROYGBIV order, which is useful because it naturally separates your warm-toned clothes from the cool. If you tend to dress in more neutral tones, try a gradient from lightest to darkest. Or follow a palette of your choice—whatever method will help you stick with the system. The idea is to hang similar colors side by side in the closet regardless of the type of item.

The other approach is to repeat a color story per section, which is what I do in my own closet. That means my dresses are arranged in ROYGBIV order, and then I repeat that same color order with my sweaters, my shirts, and so on. This method narrows in on the type of clothing while keeping the sections color-coordinated.

Another place where you can create a color pop just for you is your dresser drawers. Every decision, even as small as the socks and underwear you wear, is an opportunity to explore and interact with color. And keeping these spaces organized, however small they may be, is a way to add a colorful stress-free moment to your day.

Follow the same color story you chose for your closet space, but let go of perfection here if that doesn't work for you. Start with color organization so you can see what you own and do what works from there.

I personally use and prefer the folding techniques described in Marie Kondo's book *The Life-Changing Magic of Tidying Up*, but there are lots of alternatives. Explore the visual folding tutorials online and choose a method that you'll use. Folding your socks in a consistent way will help you see everything, side by side, every time you open the drawer.

Do you gravitate toward patterns and bright colors for these intimate clothing items? Do you let yourself go bold because nobody sees them? Or are you more practical and neutral in your choices? How does this color palette vary from the other clothes you wear or even the colors you chose for your home? Explore the reasons why you might choose differently in these areas.

At first I felt a little silly investing time in folding my socks and underwear, but having used this system for three years, I can

say that it has changed the way I dress. I know where to find what I need. I know when I really need to do laundry. I can easily find the specific pair of socks that go with the shoes I really want to wear. Having a system might add a little more time to your laundry process, but it will create more moments of peace in your life at the same time.

And remember—it's not only the clothes that can brighten up your closet. Why not make the closet itself colorful? Even if your wardrobe is neutral, you can add color to make you smile via the walls, the doors, the doorknobs, your hangers, your storage baskets, the shelves—all of it.

Chapter 10

ROMANTICIZE YOUR LIFE WITH COLOR

By nature, humans are creatures of habit and routine. Our minds are constantly trying to make order out of chaos. It's why we try to see images in clouds; we look for patterns to make sense of the world. For instance, you probably have a regular daily routine. Chances are you wake up and go to sleep at a similar time every day. You might eat similar foods and have a set time for unwinding with TV or reading, or even set days to go out with friends, clean, and run errands. Established routines provide predictability, which provides comfort.

Over the course of the twenty-four hours that we're given each day, we're also taking in the world around us. We are constantly absorbing color through our daily decisions, whether we're aware of it or not. And each of these decisions adds up. Stopping to notice color or making a colorful decision helps us see beauty in the ordinary. And this philosophy can be carried over into so many aspects of life.

Nearly everything we consume comes in a standard color. For example, when you think of an envelope, you probably picture a white one. But there are so many colorful options that you don't have to be limited to that. Pay your phone bill with a hot pink envelope and you create a little joy for yourself—and maybe the phone company employee who receives it.

Everyday tasks like paying bills are easy places to continue with your color journey. Some of the quick changes I'm going to talk about could happen within a few minutes. There are fabulous ways to add a moment of joy to your day with super ordinary objects. Think: your favorite deck of cards, a book of matches, your cleaning supplies!

The idea behind the following exercise is to encourage you to think actively about color. I want to challenge you to start thinking about your everyday errands in a new way. Perhaps shifting your mindset will make them more fun for you. Or maybe you'll try something new or realize something about yourself and your likes and dislikes in the process.

Let color be your guide to self-discovery. When you move color selections to the forefront of your mind and make them an active part of your thought process, you establish color as part of your daily routine.

Finding Color Where You Live

Let me introduce you to one of my all-time favorite activities: color hunting. Whether you're looking for a way to fill a sunny Saturday around your neighborhood or traveling someplace new, color hunting is the best way to fully take in the space around you. It gives you a fresh perspective on your surroundings because it forces you to slow down, to look, and to think about color.

We tend to form associative memories with everything from smell to taste and, yes, even color. When those memories are triggered, we can be transported to where they formed. For example, you might smell chlorine and instantly imagine it's the

middle of the summer and you're sitting poolside. The same goes for color. Maybe you can point to a yellow color in your house that reminds you of the lemons on the Amalfi coast of Italy that you enjoyed while on your honeymoon. That connection to color is an instant way to capture joy. Memories play a powerful role in how we see the world and how we derive happiness from it.

Our lives can be so busy that we miss or overlook those small moments and memories. When you start to think about color, what it means, and how it makes you feel, you can start to grow in your confidence when choosing ways to bring it into your life.

So what exactly is color hunting? Think of it in terms of a color scavenger hunt. You pick the colors you want to find out in the wild and then you head out to find them. Let's say your favorite color is cobalt blue. That specific shade of blue is the color that brings you the most joy. Where outside of your home in this world can you find that color? That's where color hunting comes in! It's a way to find sources of inspiration in unexpected places.

When I first discovered the act of color hunting, it helped me to fall in love with my living situation, even though I had been unhappy before then. For the first time I was able to see beauty in my neighborhood. It gave me the insight to be thankful for the details all around me.

I haven't even mentioned the very best part: This activity will cost you nothing but will give you all the inspiration you need to make your life brighter.

First things first: You'll need something to color-match. Like I mentioned in the introduction, I used a pack of Pantone postcards when I was first getting started. You may use anything you like! Maybe you have an accessory that you want to match in nature, or maybe you want to color-match the outfit you have on. If you'd like to stick to something you can toss in your bag and go, cut out pages from magazines, tear off the label of your favorite snack, or paint your own color swatches if you're feeling crafty. If you're

walking with your kids, try matching their favorite toy. Match your nail polish, hair color, or even the shoes you're wearing if you're out and about and forgot to bring anything with you. Really, anything that you're able to physically hold up close to the color you find in the wild is fair game!

You can also use this exercise to find inspiration for home décor. Start by stopping by the hardware store to grab a handful of paint chip samples. Consider pulling paint chips in colors you've thought about bringing into your own home but aren't quite sure about yet. Seeing them in person, painted on an actual surface, will give you a better feel for how you respond to the color.

Once you have your colors, it's time to get moving! Walk around your block. If you aren't finding your colors, extend your search a block at a time. Or maybe check out a new part of town and start the exercise there. It doesn't really matter where you start as long as you don't forget where you parked.

Hold your swatches up to items along your route to see if the colors match. Try to get as close in tone as you possibly can before declaring a match. You'll probably notice that you're able to find a color in the ballpark of your item or swatch, but that colors have unique undertones that make them all slightly differ-ent. That's the wonderful thing about color. Each one is so vastly different. Suddenly, red isn't just red anymore. It is cherry, scarlet, cranberry, ruby, and so on. Once you start noticing the subtle differences in colors, you are not only growing your color knowledge and appreciation, but also expanding your ability to reference more colors when deciding what to add to your life through home décor, fashion, and more.

Once you find a color match, capture it! Take a photo with your phone or a camera. Or just make a mental note. If you are carrying paint chip cards, write down what you found. And if you see that color more than once on your walk, keep adding it to the back of the card. You'll be amazed at all the things around you that have the same color but nothing else in common.

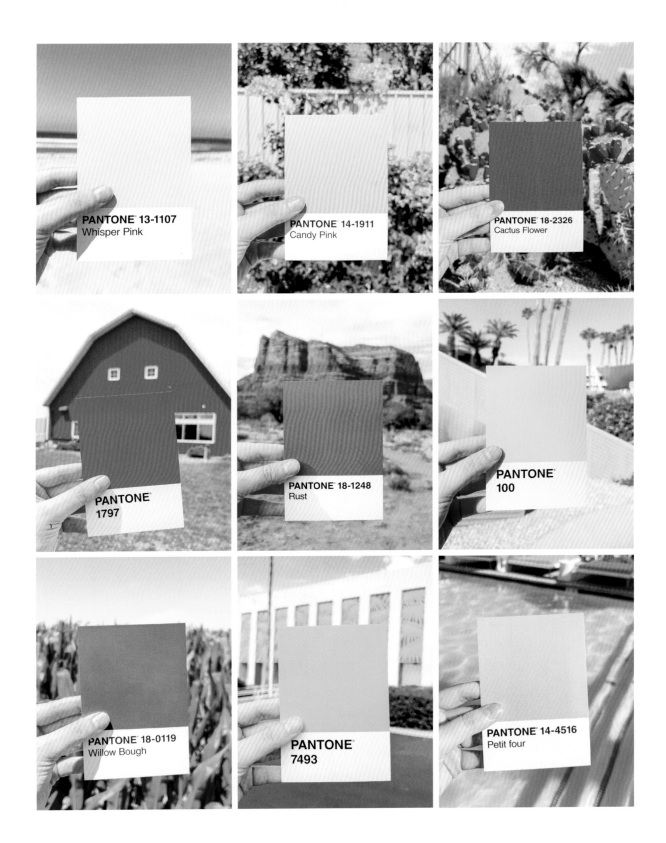

After your journey is done, feel free to journal, print pictures, or make a Pinterest board of your findings. Maybe you came across a color you didn't have cards for and can't stop thinking about. Keep it in mind for your next walk. Maybe you found a color you're now wildly in love with. Start thinking of ways you want it to appear in your home so you can see it on a regular basis. Pay attention to your feelings after you've finished your walk to fuel your color enthusiasm. And repeat this exercise whenever you're looking for inspiration.

Color Exercise: Let Color Lead the Way

Another way to discover color in your neighborhood is to take a color-guided walk. Choose a color before starting your journey and let it guide your walk.

Walk until you spot something of that color. If you come to an intersection and see the color to the right, walk to the right. Keep going until you spot the color again. See how many times you find the color on your journey.

I usually choose a standard color for this activity instead of specific shades. For example, use blue and follow any shade you find, from baby blue to navy blue, and so on. This gives you more options to move along your route.

If you're traveling to a new place and want to explore your surroundings on foot, instead of constantly consulting a map, see where color takes you.

Adding Color to Your Diet

One big and somewhat passive way we interact with color every day is through eating. We physically ingest color through the food we consume.

Color serves as a practical tool when it comes to food and has a lot to do with whether we find a meal to be appealing. You know when a piece of bread is burnt by the color of the toast. You can also tell if something is cooked the way you like (think a perfectly browned and bubbling slice of cheese pizza) or is spoiled through color alone.

Color is a way to determine the overall nutrition of a meal too. According to a post from *Harvard Health* in 2019, colorful fruits and vegetables are healthy choices to add to your diet because they contain phytonutrients. Also known as antioxidants, phytonutrients are what give plants their colors and flavors, protecting them from threats and disease while they're growing. There's a direct link between the color of produce and health benefits for humans, including for protection against cancer and heart disease.

By eating the rainbow, you add both color and antioxidants to your meal.

Brightening Up Your Workday

When you picture a corporate office space you might see gray cubicles, fluorescent lighting, beige walls, and cookie-cutter desks. Let's be honest, it's hard enough to get excited about work some days, and especially so if you work in a space that isn't inspiring.

If for you work is something to get over and done with, you might hesitate to make your work environment your own. But the truth is that most of us can't avoid work, so we might as well enhance where we spend a lot of our time. If you're working full-time, that's anywhere from six to ten hours a day—and that's a good portion of the time you spend awake! Don't settle for a joyless desk when you spend so much time there. And even if you don't work in an office, you still likely interact with a computer or desk space, whether that's to pay bills at home, to study, or as a remote workspace.

My philosophy? If you have to work, you might as well make your work life pretty. Make it colorful and create small elements of joy wherever you work. In fact, this is where you want to bring in as much color as possible to counteract working in a space that's not your own.

If your job really stresses you out, lean into the colors that bring you calm. Avoid any vivid shades that will overstimulate you. Add those colors that bring you joy without being overwhelming. If you find that you get tired or hate the office you work in, go a bit bolder with your palette. Using bright colors in a drab space adds a pop of excitement and life that will help you get through the day. Create a color palette for your office like you created one for your home to get the most joy out of your office supplies.

Here are my tips for adding color to your workday.

BRIEFCASE OR LAPTOP BAG: Whatever you carry your supplies in to and from work can be a moment to infuse color into your day. If you already have a bag you like, but it's not in the color you love, try adding a fun patch, decorative pins, or even a pattern with iron-on vinyl. If you need to use a more traditional leather briefcase, add a colorful scarf to the handle or look for a case that has bright fabric on the inside.

STORAGE CONTAINERS: Infuse color as you declutter and organize your desk. Remember that anything functional on your desk, from pencil cups to mail trays, baskets, bowls, and beyond, is an opportunity to bring in color and joy. Try adding these items in a monochromatic way or color-coordinate them to the supplies they hold (for example, a yellow bowl to hold yellow paper clips). Use different-colored binders and file folders to organize your documents. Display your binders on a shelf like you would books in your house.

PENS AND PENCILS: Display colorful pens and pencils in jars in complementary or contrasting colors. Look for pens with metal casings in an assortment of colors and patterns that you can refill with the ink color of your choice. Don't forget colorful highlighters and sticky notes. Choose colors that bring you joy to create your own personal work color story.

OTHER OFFICE TOOLS: Colorful scissors, rulers, notepads, calculators, and tape dispensers make everyday office tools more playful. Check out vintage options on eBay for unique designs. Boutique shops like Present and Correct bring an element of design to these traditional pieces. Also try colored transparent vinyl tape or dive into the world of color and pattern play with washi tape.

CORD ORGANIZERS: Keep your cords and chargers neatly organized with colorful bands. You can use reusable twist ties or a tech pouch, or even sew your own cord taco (Etsy sells handmade ones if you don't know how to sew). Try to color-coordinate your organizers to the cord, for instance, wrap your cell phone charger in green and your iPad charger in pink.

COASTERS AND MUGS: Chances are you drink coffee or some other beverage while at work, so why not make the vessel colorful?! Maybe you have a work mug set that's different from the ones at home to give yourself an extra boost of serotonin. While you're at it, pick up some colorful coasters for your desk. And a cute lunch box in your favorite color or playful tableware can give you a midday boost.

PLANTS: If your office has a window, add a plant! Or go with a faux plant if you don't have access to natural light (or a green thumb). And don't forget to liven the vessel up with a complementary color palette. Fresh and faux flowers are excellent options too. It doesn't have to be an entire bouquet; keep it simple with a single stem in a bud vase.

ART: To make your office space feel like a home away from home, add colorful picture frames to brighten up even the most generic cubicle. Bring in a personal element, like family and friend photos. You could even use a blank canvas (paint it or keep it white) as a bulletin board to display items like you would on a cork board, but with more color. Find these at craft stores like Michaels.

10 More Ways to Add Color to Your Life

One thing I've learned on my color journey is that sometimes it helps to be active and hands-on. By now, you've created a color palette for your home, decorated your walls, accented your rooms, accessorized your kitchen, started a plate collection, organized your closet, found your most flattering colors, added bling to your wardrobe, walked around your neighborhood hunting for color, and even changed up your diet. How can there be anything left to do?!

Well, there are plenty more colorful activities you can try to spark your love of color. These are super simple activities you can do at your own leisure. Think of them as low-pressure ways to interact with color. Do one per week or one per month—or do one every day if you're in need of some inspiration. These pursuits will get you out into the world around you to observe and interact with color. Have fun, repeat them often, and adapt them to fit your lifestyle.

1. **PICK A RANDOM COLOR YOU ARE LOVING LATELY AND CHANGE THE BACKGROUND ON YOUR PHONE TO AN IMAGE WITH THAT COLOR.** As a bonus, style and shoot the photo yourself. Lightroom is a great phone tool to help you brighten and colorize your photography.

2. **SPEAKING OF YOUR PHONE, ORGANIZE THE APP ICONS ON YOUR HOME SCREEN BY COLOR.** If you're a visual person, you might remember the color of the icon before you remember what the icon looks like, so arranging by color may make an app easier to find. Line them up in your palette of choice (I have all my cool-toned apps together on one screen and my warm-toned apps together on another).

3. **WATCH THE SUNSET.** Make time to watch the sun go down for at least thirty minutes to really see the variety of colors in the sky. Let yourself sit, be still, and just observe. Take note as the warm sunlight fades to cool blues. Which shades are your favorites? Did you notice any gradients? If you're a morning person, you could always switch this activity to sunrise and see how the colors change from cools to warms.

4. **DYE A NEUTRAL PIECE OF CLOTHING, OR ONE THAT MIGHT BE WORN OR STAINED.** To give new life to a piece of old clothing, go slightly darker in tone for the color. This ensures that any stains become less noticeable. Rit dye is my go-to and can be found at drugstores, fine art supplies stores like Blick, craft stores like Michaels, or online. Rit's website has DIY ideas as well as a color formula guide if you're in need of inspiration.

5. **RECORD ALL THE COLORS YOU EAT IN A SINGLE DAY.** If you want to get creative, try painting the colors you ate or take pictures of your food and make a collage arranged in ROYGBIV order. What does your personal food palette look like? Could you use this as inspiration for another part of your life? Do you like the palette? Is there a variety of colors or do you tend to eat in just a few colors? How does your food palette compare to your favorite colors?

6. **HAVE A MONOCHROMATIC DAY.** Pick a color and let it be your guide. Maybe it's putting together an outfit with different hues of the same color, or choosing a treat to match your drink, or going to a specific restaurant because their branding is the color you chose. See how many times in the day you can make something happen around that color.

7. **GO TO A MUSEUM, CHOOSE A COLOR, AND LET IT BE THE MARKER FOR WHICH WORKS OF ART YOU STOP IN FRONT OF AND LEARN ABOUT.** This is especially helpful if you're in a big museum and can't decide which wing to start in. If you don't have a museum in your area, try this activity at the library! Let the color of the book spines lead you to new genres and titles and check out a book by color.

8. **TAKE PHOTOS ONE HOUR BEFORE SUNSET, AKA, THE GOLDEN HOUR.** It's an ideal time for photographers because of the softness and warmth the light brings to everything. Even if you're not a photographer, you can still enjoy and experiment with this lighting. On a sunny day, take a photo outside or inside by a window during this time, either with your phone or a camera. It can even be a selfie. Notice how the colors shift when a warm filter (in this case, the natural one from the sun) is placed on them.

9. **CHANGE YOUR SHEETS FOR A MORE COLORFUL OPTION.** They are sort of a hidden pop of color because you don't fully see them until you're in bed. Maybe this is a backup pair of sheets for when you're doing laundry. You could also dye your own sheets! Buy cotton bedding in white and add your own color.

10. **PICK THREE TO FIVE COLORS AND USE THEM TO CREATE A BOUQUET OF FLOWERS.** You could write a bunch of colors down and choose them out of a hat, or text a few of your friends and ask them to pick their favorite color. How you determine the colors is up to you. Head to the grocery store or the flower shop, or, if you're able, forage in your yard and see what you can create.

Conclusion

Life with Color

Even though I started my own personal color journey almost a decade ago, I still find myself learning something new each and every day. You would think that after ten years of working with color I would have it all figured out. But while many color pairings and combos come easily to me, I still find that I've barely scratched the surface of all there is to know and enjoy. Whether it's finding a new color I didn't know about before, or just my personal taste evolving, the one thing I can tell you when you start adding more color into your world is that your options become endless.

Bringing color into your life and your home is a lifelong journey, but, thankfully, it's one that doesn't get boring. While I know the idea of limitless color choices can be a little overwhelming, I've found it to be more liberating than anything else. Because really, how can you get it wrong? And who has the authority to tell you that you're wrong when it's such a personal preference? There can only be one right answer, and that is, if it makes you happy, it's the right color for you.

Now, if I had to narrow down the major takeaways I've had throughout my years of exploring color, the following are some of my top lessons:

YOU DON'T HAVE TO SETTLE FOR OKAY. Between countless product options and DIY possibilities, you never have to use the default color. Or the one the stores are trying to sell you. There are more options out there if you put in a bit of time. For example, you don't like the color of your sofa? Reupholster it! Don't like a wall color? Paint it! Want a hair color that fits your personality? Dye it! While it might take more effort on your part, there's always a way to get something in the color that you really want.

CHOOSING ITEMS IN COLORS THAT I LOVE HAS HELPED ME SHOP AND SPEND LESS. Who knew that color exploration could be a good financial tip! Because I've invested the time into finding the colors that bring me joy, I am happier with my choices. I take the time to really consider my purchases versus buying on impulse. Because I love and appreciate what I have, I have less of a desire to shop and spend on something new. Putting the time into creating a cohesive color palette also reduces impulse buying.

EXPECT YOUR COLOR PREFERENCES TO CHANGE OVER TIME. We're constantly growing and learning as humans, and it's okay to change your mind when you learn new information. The more you acquaint yourself with colors and explore the different hues and shades, the more your favorite colors list will expand. As time moves on and seasons come and go, you might find yourself gravitating toward new colorful options. It's perfectly okay to evolve; nothing is locked in forever. Allow yourself the freedom of having a new favorite color.

GOING OUT OF YOUR WAY TO MAKE SURE YOU CHOOSE COLOR IN LIFE WILL ALWAYS BE A DECISION YOU HAVE TO MAKE. You can, of course, rely on default colors when you have to, because sometimes it's just easier to buy those white envelopes

than to run around town looking for sky blue ones. (Hint: Paper Source is a great resource for colorful envelopes.) At the end of the day, you have to pick your battles and decide what you're willing to go above and beyond for. When I notice that I'm making the default color choice more frequently, I try to find new ways to keep myself engaged, either with color exercises or challenges. It takes energy to choose color time and time again. But attending rotating exhibits at museums, taking color walks, reading a new book on color, and even just making time to browse for new paint colors are easy ways to refresh and feel inspired again.

YOU MIGHT HAVE TO MAKE COLOR COMPROMISES, especially if you share your space with a partner or roommate. But a compromise isn't a bad thing! You don't have to have total color control to create a home you love. In fact, I've found that living with others has helped me to evolve my palette by being introduced to their favorite colors. My husband's favorite color when we met was purple. Truthfully, I never took a second look at or really considered bringing purple home before I met him. But it has been fun to discover the various tones and shades of purple and to mesh them with my favorite colors as well. The other day I looked in my closet and noticed that I have multiple pairs of lavender shoes. People will influence you with their colors if you're open to it.

THERE'S NO PRESSURE WHEN IT COMES TO COLOR. It's about joy and tapping into a part of yourself that isn't afraid to like what you like and to be free. Don't be hard on yourself and let your inner voice be heard (read: trust your gut). If you're caught up in having the perfectly styled, colorful home that's ready for social media, then you've already lost. Because exploring color should be for YOU—not for anyone or anything else. If you're not having fun, take a break or pivot into another activity. Come back when you're in the headspace to enjoy color for what it is.

Congratulations! You made it to the end of the book. This is a bittersweet moment for me, because this is where I leave you for now. But before I go, I want to give you just a few more tips to help you keep color at the forefront of your life.

- Go someplace new for a change of perspective. Often when I find myself in a color or inspiration rut, it really helps me to go somewhere I haven't been before. This could, of course, mean taking a trip, but that's not always feasible. Try treating your town like you're a tourist. Go to a coffee shop or boutique you've always wanted to pop into. Revisit a place you haven't been to in years, or shop at a new grocery store.

- Visit home stores when they change up their seasonal décor. You can window-shop for free inspiration and to take a pulse on what's on trend for the moment. Wander in and take in the new scenery (of course, take note of the colors while you're there). Use this to explore new colors, fonts, patterns, fragrances, and textures. Anything that stimulates your senses and gets the creative part of your brain charged up is a plus. Getting out of your routine from time to time brings in fresh colors and a new appreciation of where you live.

- Often when we get busy, we forget to pause and take note of the small details, like color, that are all around us. Take a walk and appreciate a color for a moment. It could be the color of new spring grass that you've noticed for the first time. Even walking to the parking lot after work, take notice of the colors of the cars to see if there are any fun combos. My favorite activity is to find primary colors in the wild. Stepping out to your mailbox, take a second to observe

what shade of blue (or gray or white or . . .) the sky is that day. Sometimes all it takes to reset your frame of mind is a moment of pause and appreciation.

- Check in with how you're feeling. Are you still filled with joy by the colors you've chosen as your favorites? Or are you feeling like you need to change things up a bit? Revisit the color quiz on page 45 when you feel like you need a change. Expose yourself to color purposefully to make sure it's still giving you that spark.

- Was there a place, an item, or even a moment when you first realized you were having fun with color? Intentionally put yourself in that position again to remind you of your joy.

- Just keep trying. This is a process and an active one at that. You don't have to do a colorful exercise every day to keep evolving. As time passes, you'll naturally be drawn to new colors and interests. But if your color journey stops as soon as you finish this book, then you'll be limiting yourself from all the colorful possibilities out there. It helps to have that voice in the back of your mind telling you to **CHOOSE COLOR** when you're making decisions for your life. Write it down, recite it, and repeat it going forward.

Remember, there is always color for those who want to see it.

Acknowledgments

Thank you to those who not only bring color to my world, but also played a hand in making this book come to life:

Sarah Rivero Khandjian of Sarah Hearts, M. J. Adams Kocovski of Pars Caeli and @theresgoodinstore, and Julie O'Boyle Sharp, thank you for sharing your styling expertise, insightful feedback, and, of course, your friendship. To Jeran McConnel of Oleander and Palm, I'm beyond grateful for your styling expertise throughout this process. Thank you for creating (and photographing!) some of my favorite images.

Allie Provost, thank you for capturing my colorful headshots and allowing me to showcase your beautiful home throughout the book. And thank you to Dream Loft Studio for serving as the perfect pink backdrop!

Thank you to designer Kelly Mindell and photographer Jeff Mindell for sharing your colorful world.

To my agent, Lilly Ghahremani, thank you for yet again being one of my biggest supporters and believing in me. I would have never done this without you. To my editor, Julie Bennett, designers Francesca Truman and Emma Campion, and the wonderful Ten Speed Press team, thank you for bringing my creative vision to life in a way that I never even dreamed of.

Lastly, my family support system, which I am so lucky to have: My parents, for always being positive and encouraging me to go for it. To Jim, Allison, Maddie, and Ruby for your support (and for letting me use your stunning kitchen). To my daughter, Evelyn, for keeping me company as I wrote this book (while pregnant with you!). And last but never least, to my husband, Ryan. There aren't enough words to express how thankful I am to have had your support with this project and with life.

Index

All photographs are by Rachel Mae Smith with the exception of images
on pages 6, 71, 76, 89, 95, 119, 170, and 196 by Allie Provost; pages 18,
98, 106, and 190 by Jeff Mindell; and pages 104, 132, 162, and 205 by
Jeran McConnel of Oleander and Palm.

Typefaces: Latinotype's Mohr Rounded, Monotype's Walbaum, and
Laura Worthington's Fairwater Script

Library of Congress Cataloging-in-Publication Data
Names: Smith, Rachel Mae, author. Title: Colorful living : simple ways
to brighten your world through design, décor, fashion, and more /
Rachel Mae Smith. Identifiers: LCCN 2023046202 (print) | LCCN
2023046203 (ebook) | ISBN 9781984863072 (hardcover) | ISBN
9781984863089 (ebook)
Subjects: LCSH: Color in design. | Color decoration and ornament.
Classification: LCC NK1548 .S65 2024 (print) | LCC NK1548 (ebook) |
DDC 747/.94—dc23/eng/20240126
LC record available at https://lccn.loc.gov/2023046202
LC ebook record available at https://lccn.loc.gov/2023046203

Hardcover ISBN: 978-1-9848-6307-2
eBook ISBN: 978-1-9848-6308-9

Printed in China

Editor: Julie Bennett | Production editor: Natalie Blachere
Designer: Francesca Truman | Art director: Emma Campion |
 Production designers: Mari Gill and Faith Hague
Production manager: Jane Chinn
Copyeditor: Alison Miller | Proofreader: Rachel Holzman |
 Indexer: Ken DellaPenta
Marketer: Joey Lozada

10 9 8 7 6 5 4 3 2 1

First Edition